Art and Knowledge

By the same author

The Aesthetics of Modernism
Anthology of French Poetry
Britain and France, the Unruly Twins
Columbus's Isle
Contemporary French Poetry
Corsica, the Scented Isle
The Eagle of Prometheus (*poems*)
T. S. Eliot, Poet and Dramatist
France and the War
France and the Problems of Peace
The French Contemporary Theatre
Impressions of People and Literature
Landmarks of Contemporary Drama
Lights in the Distance (*poems*)
Mary Stuart (*verse play*)
The Necessity of Being
Paradoxes (*poems*)
The Poetic Drama of Paul Claudel
Realism and Imagination
Reflections on the Theatre (*translation*)
Religion and Modern Society
Symbolisme — from Poe to Mallarmé
The Time of The rising Sea (*poems*)
Twentieth-Century French Thought
White Temple by the Sea (*poems*)

Art and Knowledge

JOSEPH CHIARI
Docteur ès Lettres

Paul Elek London

Published in Great Britain 1977 by
Elek Books Limited
54-58 Caledonian Road London N1 9RN

ISBN 0 236 40017 7

Printed in Great Britain by
Unwin Brothers Limited
The Gresham Press, Old Woking, Surrey
A member of the Staples Printing Group

10002SSO9

Contents

Preface

Art is an integral part of existence. The world's art galleries, monuments, individual and public collections, to say nothing of each individual's imaginary museum, testify to this fact. Thence the unavoidable questions: What is art, how does it come about, what does it represent for man, society and history? Twenty-five centuries of arguments and analyses by philosophers and artists have provided many answers, but none final, for that will never be possible as long as man lives. There is no need to rehearse these arguments here.

Sufficient to say that the concept of beauty in art is a very fluctuating one, whose norms, varying according to time and place, can be inferred neither from man's need for them nor, least of all, from established ethical systems. The search for aesthetic norms oscillates between fixed metaphysical concepts of beauty—as was the case with the Greeks and with Kantian and Hegelian idealism—and historically changing concepts of beauty, changing according to man's relation with transcendence and with society and history. The historical approach, which is both existential and phenomenological, without being purely relativistic, seems to be the most reasonable one, provided it eschews uncalled-for Marxist confusions of art with propaganda and social realism, cleavages of art into content and appearances, described in Marxist terminology as 'realism' and 'formalism', or equivalences of art with revolution. If Marxism is action or praxis within phenomenal reality and not theory, art is negation or nihilation of phenomenal reality, to be replaced by the reality of the mind and the imagination, embodied in the work of art.

Art is inherent in man as a social being, and the normative notion of art partakes of this basic reality. Therefore, on the

one hand one has the concept of art as a spiritual aspiration of man and as a means of meeting this aspiration, and on the other hand one has the concept of art as the expression of the infrastructure of the religious beliefs and politico-economic tensions of society. This being so, the norms ascribed to art can emerge only from a confrontation with and an examination of individual works, both as expressions of moments in time and as part of a pattern which holds all works of art together and embraces the whole history of man.

Two basic principles underlie this study. The first is that the artist and the philosopher, both intent upon the search for truth and its value in society and history, are engaged in a task which necessarily posits knowledge of the whole history of the art and philosophy that preceded them. Neither of them can attempt to grasp the truth of the moment when he lives, without knowing the truth of the past; neither of them can attempt to make new, without knowing what has already been done. A philosophy or a work of art possesses a value that transcends time and place only if, by expressing and symbolising a particular human situation and subjectivity, it transposes them onto the plane of the universal and of man's perennial relationship with his fellow beings and with the cosmos.

The second basic principle of this study is that the present continuously modifies the past, and becomes the past, which has to be continuously reassessed in the light of changing historical conditions and human sensibility.

Art is the incarnation of the spirit of man in perceptible forms. It exhibits both diachronic continuity and synchronic interrelationships of essential elements of life at given moments in time. None of these elements can be fully understood in isolation from the others. The ideas of Plato or Aristotle are part of the world of Sophocles, Euripides, Pheidias, Praxiteles and Pericles, and those of Hegel, watching in amazement at Jena the spirit of the world on horseback, are also those of his contemporaries, Beethoven, Goethe, Schiller, Napoleon and David. Art expresses essential aspects of existence; philosophy and politico-social action express others, while religion underlies them all. Together they constitute stages of human knowledge, which, irrespective of phenomenal appearances, hold together, and must be viewed

as wholes, and also as part of the continuity of history. The chronological tables at the end of this study are intended to illustrate this point.

Men and gods die each other's life, live each other's death.
HERACLITUS

To see a World in a Grain of Sand
And Heaven in a Wild Flower,
Hold Infinity in the palm of your hand
And Eternity in an hour.

WILLIAM BLAKE

A man born and bred in the so-called exact sciences will,
on the height of his analytical reason, not easily comprehend
that there is also something like an exact concrete
imagination.

GOETHE

1

Art and the Artist

Because those imaginary people are created out of the deepest instinct of man, to be his measure and his norm, whatever I can imagine those mouths speaking may be the nearest I can go to truth.

<div align="right">W. B. YEATS, Autobiographies[1]</div>

We are living in an age of pragmatic knowledge, positivistic philosophy and attitudes that ignore, or at any rate underplay, the importance of imagination or intuition in the arts, in philosophy and, of course, in science. In a world deprived of the Divine, or in which the Divine is in abeyance, as is the case with ours, man can only aspire to be God, and to create his own divinity. Nietzsche dreamt of the superman and of the Eternal Return; our dreams are those of men engrossed in the satisfaction of the moment which has neither past nor future. We ban heroes, or any hope of having heroes; we make them with television cameras at every street corner, and in our homes, ready to confer upon any little man or woman a celluloid immortality. Christ Himself has to be turned into a super-star; Van Gogh becomes Kirk Douglas, and Toulouse-Lautrec Mel Ferrer, in films in which the Paris of *la belle époque* matters more than the paintings of the supposed central characters of these films. We make and unmake governments in the glare of television lights. Life is a game played by men in a hurry to catch and to hold an ever-elusive present, to make it yield its fleeting meaning and then to discard it, as if it were a squeezed lemon.

The divinity of our age dominated by scientism is science, which affords those who believe in it the shallow comfort of

so-called objective, scientific criteria of knowledge and morality, excluding of course from these two domains art and religion, which are looked upon as purely subjective manifestations of the human psyche. Those who think so conveniently ignore the fact that every aspect of knowledge which is not confined to mathematics or, if it were possible, to the purely mechanical recording of percepts, involves, for science as well as for art, mental structures and imagination, and is therefore, in varying degrees, subjective, that is to say more or less imprinted with the essential subjectivity of the knower. This varies, of course, according to the scientific disciplines. In disciplines like biology and chemistry, in which observation and the discovery of the laws of matter take place on a scale that confines the role of the imagination to that of hypothesis-making, the impact of the subject on the object is at its lowest, and the laws of verification and refutation can be used as reasonable criteria of truth. The problem is different with certain aspects of physics and mathematics involving the study of fields of activity which carry with them a large amount of imaginative work and hypothesis-making.

Notwithstanding his rejection of hypotheses, Newton could not fail to make use of them. Besides that, in the domain in which he was operating, the knowledge which he or anyone like himself contributes is always, in some respects, relative and temporal. As it never is totally verifiable, one can only say that it offers greater validity than any other competing theory at a given moment in time, but inevitably it will be superseded by a more wide-ranging theory which will incorporate it and go further. The subjective-objective dualism is, in the last resort, insoluble. Man is both an individual, leading an individual life, and part of a society and of the reality of history and creation. Even the most objective discoveries are the results of the endeavours of a subjectivity. On the other hand, subjectivity can know itself, and be known to others, only through the objectivity of art or of phenomenal reality.

The fact that art is, in all its aspects, whether creative or interpretative, a subjective activity, does not mean that its appreciation can be reduced to a pure and simple question of likes and dislikes, and that there are no criteria of assessment or of values. Such relegation from rationality would reduce

2

art to the domain of superficial affectivity and deprive it of its roots, its reality and its social and historical meaning. It would reduce art to mere entertainment and decoration, the layer of cream on the cake of life, or a form of escapism for bored, superficial existences. This attitude towards art is, of course, not new. The philistinism of the end of the nineteenth century led true practitioners of art in France, for example, in contradistinction to the satisfiers of public taste, to go underground and to express themselves through a form of art which excluded the 'bourgeois', and could only be appreciated by the initiated few.

The true poet, painter or sculptor looks upon his work as an organic manifestation of his essential self, intent upon expressing and revealing various aspects of truth — whether it is the truth of the human psyche, or the truth of human society at a given point in time, or a truth which transcends time. A genuine artist, truly aware of his gifts, believes that he is destined by God, Providence, Nature or what one likes, to fulfil the functions determined by the talent or genius with which he has been entrusted. Thence his conviction, not unlike that of the saint in this respect, that his personal life is not important, that it is what he does and what he leaves behind him that matters, and that it is his work and its import, and nothing else, that ought to claim the attention of his fellow beings. The artist is certainly not a St Francis shedding his wealth and leading an exemplary life of poverty and brotherly love; he can, on the contrary, be very worldly and much attracted to power and wealth; but whether he is called Shakespeare, Racine, Rembrandt, Picasso or Van Gogh, he is devoted to his calling, does not allow anything to interfere with it, and is more concerned with it than with his life — unless, of course, he is an exhibitionist like Salvador Dali or Oscar Wilde. But then, the man who felt the need to add a moustache to the *Mona Lisa*, and the man who flaunted his homosexuality and wanted to dazzle London, are above all performers, ever in need of an audience to bring out their natural talent, in the same way that moderate heat brings out the scent of flowers. Left to themselves, they wilt, they close up like certain flowers at night, or they fade away like the trees of the Berkeleyan quad.

3

'Most genuine artists', said Auden, 'would prefer that no biography be written'; and discussing Shakespeare's sonnets, he said: 'We know almost nothing about the circumstances under which Shakespeare wrote these sonnets . . . This has not prevented many very learned gentlemen from displaying their scholarship and ingenuity in conjecture . . . What I really object to is their illusion that, if they were successful, if the identity of the Friend, the Dark Lady, the Rival Poet, etc. could be established beyond doubt, this would in any way illuminate our understanding of the sonnets themselves. Their illusion seems to me to betray either a complete misunderstanding of the nature of the relation between art and life or an attempt to rationalize and justify plain vulgar idle curiosity . . . Even the biography of an artist, if his life as a man was sufficiently interesting, is permissible, provided that the biographer and his reader realize that such an account throws no light whatsoever on the artist's work. The relation between his life and his works is at one and the same time too self-evident to require comment — every work of art is, in one sense, a self-disclosure — and too complicated ever to unravel'.[2]

These are the words of a poet who knew his trade, and who could coolly analyse the workings of his mind, and they seem to be incontrovertible. The creative mind puts the essence of the artist's life in his creations, but this essence is the result of transmutations, and of long years of subterranean transformations which make it impossible to relate its incarnation in art to any single event or moment in his life. Any event, any moment can trigger off a creative experience which from then on takes its organic, exploratory course towards an end and an artefact in which none of the parts can be detached from the whole and restored as such to the texture of everyday life. No amount of psychological cogitations or explorations of the facts of Michelangelo's life will ever tell us why he gave to the *Rondanini Pietà* the unique, moving shape and the spirituality which emanates from the interplay of the two figures that compose it. Never has the concept of mother and son reached such tragic depths of suffering and ineffable love. One single, eternal womb seems to enfold and hold for ever in a fulgurant moment their entwined births and deaths. Never has a human mind come closer to suggesting the mystery of

4

the divine act of creation which embraces, in the same flash of lightning, life and death.

Without being extremely Berkeleyan or Schopenhauerian, to the point of looking upon the world as the will of the onlooker, one must surely concede the point that facts and circumstances are what the individual makes them and makes of them. Bastardy, homosexuality, marital unhappiness, unrequited love, all these aspects of human life are the lot of millions, out of which only a handful are singular individuals possessing the capacity, through genius, to give shape to objective, universal truths. Genius is not made up from conflicts with dour Rimbaudian mothers, or from lack of a legitimate mother or father; it is webbed with the structures of the mind which exist before this very mind reaches the stage of being able consciously or subconsciously to ask what sperm might have fathered it. Genius is the seedling which has sprung, more directly than any other, from the womb of the earth, and which, more than any other, is solidly and widely tied to it, in a way that enables it constantly to draw from it through imagination, and to reveal to the rest of creation the mystery of its source and its finality.

Simone Weil, writing about a biography of Marx, rightly suggested that 'to write the life of a great man as though it were something distinct from his work, is to bring out the mean and petty side of his character, since he has put the best of himself into his work'. Admittedly, a poet's biography can be interesting reading for those who like to read biographies, but it certainly does not help either the apprehension or the appreciation of his poetry, and as for the understanding which it may contribute to it, it could also be a cause of confusion and unwarranted equations of the poetry with facts and events of the poet's life. A poem is an imaginative entity with a life of its own, and not a chronicle of facts or a report of the incidents or emotional events of the life of the poet. Whatever is in it is part of a whole, in which existential reality has been totally transformed by the fact that it has become an organic, component element of the poem.

To know that the 'we' of 'We took the wrong turning' in *Burnt Norton* might have been addressed to a real human being, and not to a fictitious one, does not contribute anything

at all to our appreciation of the truth and intensity of Eliot's poem. The important fact is that, at one time or another, in one way or another, we all take wrong turnings, with friends, with lovers or with close relations, and as time is unredeemable, once we discover — as we always do — what we have done, we can only regret and ache. Whether Beatrice Portinari truly lived, or ever met Dante in real life, is of no importance. We can be sure that she certainly could not be the Beatrice of *The Divine Comedy*, the one who incarnates all the Beatrices of creation and who will live as long as man. The fact that Baudelaire's mistress was a mulatto for whom he felt, at one and the same time, both love and disgust, is of no importance for the appreciation of *Les Fleurs du Mal*. Jeanne Duval, instead of being a mulatto, could very well have been a white courtesan; the result for Baudelaire, as well as for the reader of his poems, would have been exactly the same.

A work of art is beyond good and evil, in the sense that, if it is aesthetically satisfying, that is to say if it meets certain prerequisites of art which will be discussed later, it cannot fail to be moral. The relationship between talent or genius and character is accidental, and therefore one cannot by any means judge one by the other, or in terms of the other. A man of talent or genius may well be a bad character, and is often so, but one cannot decide whether or not he is a bad poet or a bad painter because of the fact that he is a bad character. Villon was a robber and a pimp, but his poetry is not only accomplished poetry, but also great poetry, and as such it is necessarily also morally good poetry pervaded with the sense of the Divine. La Belle Margot was a whore with whom Villon intermittently lived, yet the poem *La Belle Margot*, like *La Ballade des Pendus* and most poems of the *Grand Testament*, plumbs the depths of the human soul and leaves the reader as overwhelmed with wisdom and humility as when he has been made to contemplate the great infinite which terrified Pascal, for, as in the case of Pascal, such poems give him the courage to confront his nothingness.

A creator's duty is first and foremost to his art, for it is only by being absolutely faithful to the laws of his art that he will avoid artistic immorality. He will indeed become immoral if he prostitutes his art to serve inhuman causes, in the same

way as scientists become immoral if they adopt the point of view that, as men of talent or genius, they are above ethical norms. Artists' lives are not above ethical norms, yet their work, often distorted, as is the case with Nietzsche's, must not be judged by these norms. The artist, the scientist or the philosopher is part of society; each is meant to carry out his work, and to make his contribution to society according to his gifts. His moral failings should certainly be judged by the ethical laws which apply to all, yet, while these judgments are being made, a final reckoning should never fail to take into account the services that each may have rendered in his own specialised field of activity.

It is not without significance that a painter like Picasso no more wished to be described as an artist than Bertrand Russell wished to be described as an intellectual. These two terms are obviously limiting and restrictive, and they both carry suggestions of professionalism which ill accord with the single-minded vocation of the poet, the painter, the sculptor or the philosopher. Michelangelo wrote to his nephew and asked him not to address letters to him as 'Michelangelo, sculptor', because he was known only as Michelangelo Buonarroti; and if a Florentine citizen wanted someone to paint an altar-piece, he must find a painter; as for himself, he was neither a painter nor a sculptor in the manner of keeping a shop. He was in fact a gentleman who at times painted or sculpted, if he felt like it. Picasso's obsession was with painting and with discovering, through it, the mystery of forms, the meaning of certain human experiences and the true nature of man. Picasso said, 'I was a painter', and not 'I was an artist'—a word that he used only derisively.[3] Young Correggio, in his famous 'Eureka' moment of revelation in front of Raphael's *St Cecilia*, did not say: 'I too am an artist'; he said: 'I too am a painter.' The saint-like devotion of Van Gogh, Gauguin or Picasso to painting, or of Mallarmé to poetry, precludes the use of the word 'artist' in order to describe them, in the same way as the total commitment to their work of Bergson, Whitehead, Russell or Sartre precludes the application of the word 'intellectual' to them. The word 'intellectual' conjures up the idea of a technician of knowledge whose task or profession is to impart conceptual knowledge and information to those who

7

are willing to listen to him or in need of listening to him. He deals in abstractions and he himself is abstracted from the information he imparts. True philosophers are always subjectively involved in the system they create or expound, and they are, above all, not distributors of concepts and data, but seekers after truth and wisdom.

The creative artist, in contradistinction with the artist as 'artiste', does not require an audience in order to express his talent or genius, though no doubt he is likely to welcome one once he has completed his work. His task, his purpose, is not to interpret or to give existential reality to something that exists already, but to give to forms, essences or 'airy nothing a local habitation and a name', that is to say to embody essences into organic entities or constructs that are works of art. A performance or an interpretation is, like religious experience, purely subjective, while a work of art is both subjective and objective; it is an objectified subjectivity which becomes the existential basis of any number of subjective interpretations or performances. A play, a poem or a painting, whether or not it is performed, read or seen, exists; it has a life of its own, waiting to participate in, and to become, a life for others. A performance of, say, a play has no such existence, it is only a lived experience that lasts the time of the performance, and if this performance is recorded or filmed, it is neither a work of art in its own right, nor the original play, but merely an interpretation: that is to say the subjective recreation of an objective-subjective reality which is endowed with a self-to-self-generating life of its own. Artistes who, like Sarah Bernhardt, Maria Callas, Edmund Kean or Marlon Brando, lead flamboyant lives, are ideal subjects for biographies; so are artists as performers, like Boswell, Wagner, Oscar Wilde or Dali; but poets, sculptors, painters and composers do not need biographies.

We live in an age of biography, an age that takes more interest in historical fact than in spiritual knowledge. We are more interested in Racine's loves, and supposedly murky doings with Mademoiselle Du Parc than in *Phèdre*, or in Wordsworth's love for Annette Vallon than in *The Prelude* or in *Ode on Intimations of Immortality*.

The desire to know how a great writer or painter lived is

understandable, provided this curiosity is not turned into a prerequisite of aesthetics, to explain the work of art in terms of the life of its creator, that is to say a form of crude determinism that seeks to establish constant causal relations between art and life. This necessarily brings in psychoanalysis, together with its pseudo-scientific claims, its unavoidable distortions and, last but not least, the prejudices and biases of the analyst. So that all too often one overlooks the fact that the man is one thing, and genius in art is another; the two are not interchangeable and one cannot, by any means, understand one through the other. One must not forget the fact that it was Stendhal and not Monsieur Beyle who wrote *La Chartreuse de Parme*. The artist as man is concerned with life, the artist as artist is concerned with art. The triumphs, the difficulties and failures of art are not those of life, and vice versa. Leonardo Da Vinci wasted a great deal of time in what now look like second-rate, yet were in his time primary tasks, while tossing off masterpieces in his supposedly spare time. His notorious obsession with a phantasmal vulture, which Freud and his followers claimed to have detected in *St Anne*, loses its point if one bears in mind the fact that this so-called vulture is merely a patch of white that carries absolutely no drawing to mark out its outline in a vulture shape. And Leonardo did not even paint the patch of white in question, but had it painted by one of his assistants. The psychoanalysts' desire to turn supposed 'facts' of an artist's life into explanations of his work has resulted in many masterpieces being explained away in terms of vultures, obsessions, inhibitions and imaginary or real disorders of all kinds. In fact, the only type of biography an artist should have is that which would deal with the growth and development of his mind, a kind of complete Wordsworthian *Prelude* in prose.

It would not, of course, be true to say that the events and facts of an artist's life have no influence or effect on his work. They have, but in unanalysable ways. What is food for some is poison for others; in a similar way, facts and events are received and transformed according to individual affectivities. Art is imagination, and truth and beauty in art can be achieved only through the artist following the bent of his genius. Villiers de l'Isle Adam's comment: 'As for living, we

9

leave that to our servants' is, admittedly, pure aestheticism, conforming with the late nineteenth-century revulsion against materialism and with the ivory tower mentality of bruised artistic sensibilities of his age. Yeats knew better when he said that it is out of the quarrels with ourselves that we make poetry, for his frustrations with Maud Gonne, his rage against old age, his burning concern with the fate of Ireland are part of his quarrels with himself and are stamped all over his poetry. Yet these events and situations found their place in poetry only because Yeats was a poet. Common frustrations and rages did not make of him a poet, they merely fed his poetic genius, which transmuted them into great poetry. Maud Gonne became for him what Beatrice Portinari became for Dante—a mythical figure embracing all dreams of unrequited love and all frustrations, including the beloved image of his motherland, shackled for centuries and longing for freedom. The difference with Dante is that he did not rise slowly towards Paradise, he remained more and more firmly on the earth. Yet what matters is that these poems, because they are the work of genius, rise beyond the personal and the singular to reach the universal, which for Yeats expresses both his own plight and that of his mother country, as well as the sensibility of the age in which he lived.

This age, being at the tail end of Romanticism and idealism, was more and more aware that truth was subjective, therefore existential, and that it could no longer be equated with Cartesian objectivity or Hegelian rationalism. 'If you look at the world rationally, it looks back at you rationally', Hegel had said. This was no longer true. Reality had ceased to be rational, because man himself had ceased to be so. Reason, like God, was dead, and with them any hope in the future; nihilism and pessimism were slowly flooding the Western world, and Eliot's *Waste Land*, rising to universality and objectivity, is not merely the confession of a distraught sensibility caught in the conflicts of life, but the expression of the sorrows and suffering of his age, gambling its fate in the shell-torn fields of Flanders. The answer to the Pascalian cry of despair and hope of *The Waste Land* had already been given by Wilfred Owen's poem *Strange Meeting*, in which Death enfolds in all-embracing forgiveness and love the suffering and

10

tragic fate of man.

'Painting', said Leonardo, 'is a form of poetry made to be seen.' 'Poetry' and 'poets' are therefore terms which apply to all the arts and to all creative artists. Poets, painters, sculptors, composers learn, like everybody else, through perceptions and personal experiences which their imaginations transform into symbolic entities in which the will-to-being of the creative mind fuses and holds together details removed from the real, though rooted in the real, and transforms them into a coherence which offers the reader, onlooker or listener participation in a vision or experience that temporarily disconnects him from the world and remains for ever part of his own spiritual life. Every true experience involved in art is part of life, but once it has passed through the crucible of the poet's imagination and the sifting process of his memory, it no more resembles or represents the perception, event or fact that may have caused it than a perfume represents, or is, the ingredients and processes required for its making.

All great works of imagination are necessarily rooted in reality, for it is this which confers upon them human truth and profundity. All creative minds work and create out of their own inner substance or subjectivity, taken at its very source, which is the point where all subjectivities meet and discover their being, which is the very being of life and of universal truth. Every man has in him the virtualities of all the aspects of human life, and the creative imagination only needs from reality a starting point to turn the fall of a leaf into the fall of the universe, the fall of a tear into bitter seas, and disappointment in love into a dark night of the soul. To the creative mind, any source, whether from life or from art, is enough to unleash transformations, which have no common measure with reality but which, on the contrary, represent an essentialised and universalised reality which is valid for all men at all times. It is this capacity for slow, telluric transmutations and ontological digestions of perceptions and experiences, past and present, and involving the whole of mankind, which is the very essence of genius. Through genius is woven the web of imaginative structures which, like a cloud reflecting the setting sun, reflects the essence of human experience at various stages of man's life, and is an endless source of enjoyment and

11

enlightenment for all those standing on the same shore and nursing the same fears and dreams. The poet sees with his mind's eye the very sources of words, the point where the word coalesces into the phonetic structure and image that embody the complex emotions and mental glimmers that brought it to birth.

This vision without eyes is that of the imagination, which Delacroix aptly described as 'the queen of human faculties'. Imagination is the human mind working at white heat, which discovers, or rather recognises, according to its strength and range, the structures and laws of nature which correspond to its own, and makes them part of human consciousness. Consciousness is the flame which feeds on life, and illumines and guides its unfolding towards its self-caused finality. There necessarily exists a perfect equilibrium between the human mind and reality; this equilibrium, though it is not quite clearly covered by Hegel's famous phrase: 'The rational is the real, and the real is the rational', means that, however powerful the human mind might be, it can no more go beyond the real than the real can outreach the scope and range of the human mind. The two are part of the same reality, which is one in its essence, and this essence is change, continuous becoming and continuous tension between now, yesterday and tomorrow, and, at the organic level, continuous, irreversible transformations and integrations of what has been in time, and progression towards what will be according to life's evolutive finality, inherent in its substance. These transformations, consciously or subconsciously absorbed at the organic level, form a kind of knowledge which renders impossible the absolutely identical repetition of any experience. In organic life, and consequently in art, nothing can ever be exactly the same; as Heraclitus said: 'We can never bathe twice in the same river', and this continuous change necessarily entails the fact that the past, which is always apprehended from the present, is continuously modified by the present. Art is always new, that is to say different from that which preceded it, though of course identical with it in its essence and finality.

The creative artist is not a ghost on the fringes of life; he is a human being, therefore his life and age play a part in his work. Genius does not consist in wilfully trying to satisfy

personal needs, pressures or ambitions, or in being shaped and moulded by environment, but in expressing and in giving existential appearance to the vital aspects of the environment in which it lives. Genius is not the result of the forces — social, political, artistic or religious — of a given age, but on the contrary tells us, according to its range and strength, what these forces truly are, by embodying them in symbolic entities that are apprehensible to all and mirrors in which the age recognises itself. *The Divine Comedy* is a monument of fire and ice, reflecting both the personal and also all the religious, philosophical, political and artistic aspects of the life of its age, as well as some of the most perennial aspects of life in general.

An individual is both an entity with his individuate form or essence, which determines and wills its fulfilment, that is to say a kind of self-contained monad, and a component element of society and of mankind, which comprises, as he does, negative and positive forces, and possibilities of growth, decay and death pertaining to all living things, but which lacks something that only the individual man and society possess in different ways — an awareness of the present, of the past and of the future towards which they move. Every work of art is not only a manifestation of individual genius, but one more light illuminating the dark sea of time and offering man the sustaining comfort and encouragement of his victories over fate, time, and the limitations of his own condition.

The forces that animate a given society are never at any time completely homogeneous, univocal or unidirectional; they are on the contrary heterogeneous, conflicting, positive and negative, and disturbed by virtualities which, though not strong enough for actualisation, play an unassessable part in the life of this society. Mind, or spirit, which informs creation, is, at all times, and is always a whole. None of the structural ideas that pertain to it are ever completely absent from it. These structural ideas are those which form the basis of systems of thought that can offer, in varying degrees, explanations of the workings of the cosmos and of man's relation with it. Some of these ideas may be, at times, in abeyance, or they may be kept in the dark by ideas that are partly or totally their opposite and that thus dominate society at certain moments of

13

history, but they never disappear; they remain alive, and they move underground until they reappear so that their positive aspect becomes then part of new syntheses and new systems. To take an example, the eighteenth century, the age of reason, aptly described by A. N. Whitehead as the age of one-eyed reason, had already been described at the time as the age of 'half-light' by a philosopher, Dom Deschamps, who lived then but who was firmly kept in the dark by the *philosophes*, who were not philosophers and who therefore disliked his views. They were the *encyclopédistes*, like Diderot, materialists like D'Holbach, Helvétius and La Mettrie, and anti-metaphysicians like Voltaire, who looked upon man as a well-regulated automaton, rational and happiness-bent, having no need of Divinity or of metaphysical speculation. Dom Deschamps' work has just been published, and makes it clear that metaphysics was not dead in his time and that its life-line, which connects Spinoza, Descartes and Leibniz to Hegel, was unbroken. There are no clear-cut breaks in the life of mankind; there are only patches of light and darkness, in which the silhouette of the landscape always varies according to the position of the observer.

Great art is never confined to the society in which it was produced, nor could it ever be produced by social groups working together. *Lear* or *Hamlet* can no more be confined to the Elizabethan age than *The Last Judgment* to that of Julius II, or *The Three Crosses* and *The Pilgrims of Emmaus* to seventeenth-century Holland. These works are our contemporaries, and they will no doubt remain contemporary to man as long as he lives. As for social groups working together, they could not produce art, though they could produce entertainment and functional artefacts. Art is essentially individual, and the inner relationships and structures of social forces find expression through art not through the harmonisation of various consciousnesses, but through the consciousness of one single subjectivity possessed of the gift of connecting with other subjectivities of which it is both the voice and the light.

Genius is part of the subterranean essence or spirit which informs life and every now and then manifests itself in creations that enable man to know where he is, what he is, and the direction that life and history are following. The perenniality

14

of genius must not be turned into the uniformity of genius. The man of genius expresses perennial aspects of life at given moments, and beyond such moments, but he expresses them in a way that belongs essentially to himself and to no one else, whether he expresses philosophic beliefs or systems which span different ages, or, in concert with others, aspects of the age in which he lives. Blake, Hegel, Bradley, Yeats and Whitehead, for instance, all express, at different times, aspects of neo-Platonism, yet each does so in his own individual way. Eliot and Pound, though both American-born and contemporaries, did not speak with the same voice, nor with that of Yeats, Valéry or Rilke. Yet each of these figures, irrespective of his individual upbringing and background — which in the case of genius are always more or less subsumed in the greater forces at work in the age — shows that he belongs to the same age as the others, and that he could never be looked upon as belonging, for instance, to the age of Poussin or that of Wordsworth or Delacroix. Eliot is further away from Yeats than he is from Joyce, Valéry or Picasso, whose nihilism and experimentalism he shared during certain periods of his life. This nihilism, the nihilism of a world without values, a world searching for new beliefs or for the renewal of old beliefs, is as much part of his age as the existentialism of Yeats and Valéry, one of whom in the end rejected the romanticism of his youth and the other the nihilism and idealism of his early poetry. Genius has its own tropism, which leads it to feed on whatever satisfies its own inner laws and structures, and these inner laws and structures are the essential correspondences which exist between it, society and man in general, and thus make it possible to recognise and to reveal the affective and mental structures of socio-historical groups of varying importance and the strength of the positive forces which foster the growth of consciousness and the enrichment of life. The range and depth of these correspondences are the measure of the importance and significance of creative genius; therefore the elements that matter most in the appreciation and assessment of great art are those concerned with the human in general, and those related to the past, present and future of the society to which it belongs.

The work of art is not a jumble of disparate elements or a

collage of effects and influences, but an integrated coherence in which every component element has been transformed by the creative imagination and made to conform to the finality of the whole, which is to be, and, by being, to reveal what was not known before. It is both an incarnation of potentialities and virtualities, and a mediation between the invisible and the visible, and therefore when confronted with it, one must not start by presuming what the potentialities or pre-incarnations might have been or could have become, but from what actually is, for it is only thus that one can attempt to discover what were the virtualities that have been actualised. In the beginning was action; the logos, the lightning flash that started creation, is action. Creation in all its forms is action, and any attempt at appreciating, understanding or explaining a work of art must start from the work itself and not from sociological hypotheses or structural models. Models are merely Procrustean beds. Hypotheses about the causes, constituent elements and forces that compose the work are bound to carry a good deal of guesswork, wishful thinking and personal bias, since one cannot know the exact strength of the social and human forces that underlie a work of art, until they have actually found coherence and expression in it.

Art not only mirrors the present, but it has, at its best, an archetypal validity which expresses both the individual creative mind at a given historical moment and the mind and history of a race, of a civilisation, and of man himself. The greater the knowledge and awareness of history one has, the more readily the relationships and connections of a given work of art with the past, the present and the future will outline themselves and make it easier to assess the place and importance of the work of art in the context to which it belongs. This kind of knowledge necessarily excludes notions of influence and dependence, which it replaces by elective relationships, natural developments of thoughts, feelings and social structures, and affinities between socio-historical periods which present similar characteristics. Eliot did not imitate Laforgue; he shared some of his preoccupations and attitudes; he had affinities with him, and he lived in a society in which the conditions of life were, in some respects, similar to those in which Laforgue lived. He echoes the metaphysicals because,

16

like Laforgue and other writers of his age, he found in them a sensibility caught between two worlds. This was a sensibility also his own, and of course not only that of those who, as he was, were torn between a puritanical upbringing and the call of the senses (which would reduce his stature to that of a purely psychoanalytical case), but that of his time torn between despair at the loss of centuries-old values and the irrationalism and hedonism of life lived on the verge of cosmic destruction.

The fact that a work of art expresses much of the sensibility of its time does not mean that one can establish, as has been attempted by some critics, a cause and effect relationship between certain social attitudes and problems and certain creative minds. One cannot, for instance, as Lucien Goldmann tried to do in *The Hidden God* and *Marxisme et Sciences Humaines*, account for the tragic vision of Pascal and Racine by putting forward the fact that they were both members of an oppressed minority—the Jansenists—and that there was another oppressed minority—the 'noblesse de robe'—closely connected with the Jansenists and which was losing its power: 'But the existence of the tragic vision was already a constituent fact of the situations starting from which Racine achieved the writing of his plays. On the other hand, the elaboration of this tragic vision through the ideologues of the Jansenist group of Port-Royal and St Cyran came about as a *functional and significant reply* of the "noblesse de robe" to a given historical situation. The individual Racine was later confronted with a certain number of practical and moral problems in connection with this group and its more or less elaborated ideology, and this led to the creation of a work which is underlain by a tragic vision that has reached an extremely advanced level of coherence.'[4]

The fact that Pascal and Racine were Jansenists no doubt influenced their lives, but the transmutation of such influences into works of art requires genius, and genius is essentially individual. The tragic vision of life was shared by many of their contemporaries and immediate predecessors, who had nothing whatever to do with Jansenism, or with the oppressed 'noblesse de robe'. Shakespeare had just died; so had El Greco, whose awe-inspiring vision of life blends Hellas and Christianity. More important still, at the time when Pascal and

17

Racine were writing, Rembrandt—Shakespeare in painting—
was expressing his tragic vision of life through the obsessive
figure of Christ which dominates his work from *The Three
Crosses* to *The Pilgrims of Emmaus*. In France itself, if there
is Poussin whose neo-classicism echoes Racine, though with-
out his tragic vision, there are also Claude Lorrain, Le Nain
and Georges de la Tour who continue, in a subtler way, that
links them with Rembrandt, the realism of Caravaggio who
had just died. La Tour has the same poetic vision as Rem-
brandt; his use of light is similar, and nobody, not even
Rembrandt, has been able to suggest with the same intensity
the effect of night, the other-worldly atmosphere of stillness,
and the perfect blend of the human figure with this stillness;
*The Prisoner, The Adoration of the Shepherds, St Joseph the
Carpenter* are all night-bound statues, whose luminous
silhouettes transport us into another world, a world informed
with God's presence.

From the Renaissance onwards, God's transcendence is
more and more placed in abeyance, until finally only imman-
ence remains as the spirit or force which informs creation.
God has withdrawn from Nature, which has fallen through its
own fault, which is a kind of original sin. Man can no longer
connect with God unless he is redeemed through Christ, Who
thus continuously recreates man. Thence the notion common
to Protestants and Jansenists, to Rembrandt as well as to
Pascal, that life without God can be lived only in terror on the
verge of the abyss, and it can be redeemed only through
Grace; and, as Grace does not last, not even for the elect,
man has to be saved from moment to moment; thence the
terrifying thought that death could very well come when he is
deprived of it, and is unfit for salvation. Thus, Calvinist and
Jansenist man can say, not: 'I think, therefore I am', but:
'I believe, therefore I am.'

However different Descartes and Pascal may be they are
both rationalists. Descartes marks the zenith of Thomistic-
Aristotelian rationalism; Pascal marks the beginning of the
influence of the Augustinian type of rationalism, which, like
Thomist rationalism, is existential, but which, in contra-
distinction to Descartes, who leaves God in abeyance and bases
truth on subjective thought, bases truth and absolute reality

on the awareness of the existence of God. The hidden God of Pascal is the hidden arteficer of the universe of Descartes, but Pascal is not satisfied with reason and mathematics to prove truth, he needs certainty and, realising the impossibility of equating certainty with truth, he uses reason to render unavoidable the leap into faith. He reaches the same conclusions as his contemporary Locke who, living in a society which was in no way affected by Jansenism or by the loss of power of the 'noblesse de robe', not only practised a slightly different type of rationalism, but also, like Pascal, carefully separated understanding from belief or assent, yet without showing any awareness of the tragic sense of life. Pascal was a mystic endowed with a great imagination all the more terrifying in that he distrusted it, and this imagination kept him on the verge of the void, haunted by fears of eternal separation from God, a thing far more awe-inspiring than anything Racine ever suggested. Only Shakespeare, who did not share Pascal's obsessions, and in whom imagination was the mediator between the known and the unknown through concrete, living symbols, plumbs, through the dark journey and sufferings of Lear, the terrors which Pascal's mystical being had to endure but could not communicate to others.

The artist does not aim at turning into an artefact a given situation or a problem. He reveals what it truly is by taking it at its roots and by giving it, through his subjectivity, a shape and a coherence which renders it apprehensible and, in varying degrees, understandable to his fellow-beings. We know what Racinian tragedy is because Racine has written it; we could not have guessed at, and least of all constructed social structures corresponding to it, unless and until this type of tragedy had been created by the individual Racine. These tragedies are as much part of his age as Corneille's tragedies or as Madame de Lafayette's *La Princesse de Clèves*, each exhibiting in its own way the conflict between reason and passion which is part of the philosophical thought of the age which includes Pascal and Descartes. Biographical details are more often than not a hindrance in any attempt to grasp the imaginative truth of a work of art. One generally knows very little of the psychology of living artists, and nothing at all of that of those who belong to the past. Any approach to the

19

appreciation of a work of art that assumes the contrary must result in much distortion and paraphrasing of the work itself so as to make it conform with the life of its creator. This is the case, for example, with Sartre's examination of Baudelaire's or of Flaubert's works. True, Flaubert said: 'Madame Bovary, c'est moi', but if Flaubert had only been Madame Bovary, a petty bourgeois hysterically and mystically uniting himself, for all sorts of psychotic reasons, with the character of Madame Bovary, we should be confronted with a not very singular case of mental illusion, and not with a great novel. Such an approach to art is a form of conceptualism that points to a failure to grasp the very source of art, which lies at the meeting point of consciousness and subconsciousness, and which therefore must be allowed to dawn with as little conscious guidance as possible, and purely according to the affinities of the creative mind with the theme treated. Whether or not Baudelaire was a perfect sample of bourgeois life, living in bad faith, hating his step-father, taking drugs, and being eaten up with boredom, does not much matter. What matters is the power of his imagination haunted by the vision of a lost Eden, and the song with which the poet, caught in the viscosity of an unredeemable present and past, tried to liberate himself and all those who share his fate. It is these immortal songs from Hell, or from the edge of despair that all men, whose plight is similar to that of the poet, love and repeat as means of soothing their sorrows; for, however sad we might be, the immortal beauty of art is always a means of lifting us out of our own sadness and terror. The point, which on the whole eludes psychologists, is that art is an anthropological and individual activity, part of society and history, but that it is neither a psychosis nor a scientific or conceptual method of establishing correspondences between emotional states and thoughts and linguistic symbols to be deciphered by psychologists and specialists in linguistics.

With the notion of art as neurosis, those who adopt the psychoanalytic approach to art make of themselves the masters of all explanations. They lay down their own criteria of normality about social and individual behaviour, and anyone who is not in conformity with these is abnormal and exhibits evidence of neuroses or complexes which, in the case of the

artist, manifest themselves through his work, which is for him a means of attending to or alleviating them. Every artist is thus supposed to have his own neurosis which explains his style, his imagery, his obsessions, and is the reason why he is an artist. Whether or not he could be one without his neurosis cannot be ascertained, since the one hypostatises the other, and thus turns genius into a mental illness. The psychoanalytic approach can only operate at the clinical level of the pathology of art, therefore though it might have a contribution to make to literature as biography or thriller, it has none whatever to make on the plane of aesthetics. The notion, cherished by Freud and Marcuse, that looks upon art as negation of or alienation from society is part of the same psychoanalytical approach that explains art in terms of compensation for, or a drug to ease, frustration and contradictions. Alienation is no doubt part of social life, and art can, in certain cases and at certain times, express or symbolise negation, but of course even when it does so, it still is unavoidably an expression of society. The negative is not an entity described as 'what is not'; it *is* not, for in order to be a 'what is not', it would need to possess the essential property of being 'what is not'. Non-being can have no predicate; it can only be part of the becoming of being, and not an alternative to being. 'What is not' can only be the negation of 'what is'.

Art, as Nietzsche said, 'is by essence affirmation, benediction, divinisation of existence'; it is an assertion of being, and not a replacement of being by a hypothetical non-being. One can negate reality and make of this negation a transcendental act which is its own finality, but one cannot turn non-being into an entity. Art is not a means of cleansing the subconscious (though the subconscious plays a part in it), or a way of ministering to man's sensuous appetites through pornography. Pornography is not art, and it cannot be subsumed under the wings of Eros, which implies the wholeness of love in a world in which imminent essence unites the material and the spiritual and links them with Being. Pornography attends only to the body and—what is worse—the body completely unconnected with spirit. It consists above all in the stimulation of sexual appetites and desires through images or words which evoke in the beholder or reader a world of sexual fulfilment

21

completely detached from reality. Pornography can never bridge the gap between the beautiful world of fantasy and the real. The pornographic addict dreams of erotic pictures and uses whatever partner he may have purely as a physical object or an instrument of masturbation in order to obtain a satisfaction which is fostered and dominated by the dream. The result is frustration for the partner used as an object swamped by dreams, and also frustration for the one who is condemned to keep reality and dreams ever apart and therefore more and more difficult to reconcile.

Art is the essence of an artist's life; it is not, it can never be the newsreel of his life; therefore one must never confuse one with the other, or try to explain the one in terms of the other. Genius can realise itself only in oneness, whatever the despair and suffering this oneness might entail; this oneness necessarily implies a vision of life as both good and evil, and genius can transcend these divisions and reach beyond them into the perennial. Had Villon and Baudelaire lacked this vision of evil and the courage to follow their passions, their weaknesses and turpitudes to the consummation that turns them into their opposites, they would never have been the great poets that they were. Had Baudelaire been the little man living in bad faith, cultivating his weaknesses in order to punish his mother and to assuage his Oedipus complex, he would have been merely a wilful attitudiniser, playing a part which could have brought him only very feeble returns. The truth is otherwise: Baudelaire cultivated his hysteria, his dissolute and wasteful life, as part and parcel of his genius, intent upon whatever was necessary in order to fulfil it. If harlotry was as necessary to him as it was to Villon, then it had to be so, for there lay the truth of his creativity. Dante, happily married to, and raising a family with, Beatrice Portinari, would not have been Dante. He had to confront and to transcend his fate, which was to rise from despair and the deep awareness of evil to hope and to the beatific vision, in order to be his true self in creativity. Yeats, married to Maud Gonne, would never have experienced the pangs of despair, frustration and revolt which are part of his genius and are the texture of some of his great poetry. Maud Gonne had to be Helen of Troy, never part of the city in which he lived, always pacing the battlements, to be looked

at, admired, desired, but never held. The ideal beauty which filled his gaze was ever elusive and cold; the well he wished to drink from was dry; the stairs he had to climb were steep, and like Cuchulain, 'mad with sorrow', he often had to fight 'the deathless sea'.

The creative mind is what it is meant to be, and not the compound of might-have-beens which moralists and psychologists who like to see art in terms of life would like it to be. Shakespeare's characters, admirable mirrors of life, concentrate their energy on being what they are meant to be — passions, weaknesses, wickedness, evil and all; their greatness is their wholeness, and the fulfilment of their destiny. Illumination and revelation, and not morality, are the main objects of art; good and evil are part of the transcendence which art seeks to achieve, and some of the greatest artistic creations are all the more beautiful and rich in feelings because they are completely sterile, in as far as any possible political, ethical or religious proselytism is concerned. Art is part of history and also transcends history; whether it deals with the destruction of Troy or the crushing of rebellions, it can give rise to masterpieces which completely negate the facts that prompted them, and leave us with pity and love for the noble suffering of man. Few people know the name of the Popes who employed Michelangelo; everyone in the world knows the name of Michelangelo. In the end, it is the world of art and of the creative artist which constitutes, perhaps more than anything else, the eternal world of history.

2

What is Art?

We arrive at our limited knowledge by discursive reason from
conclusion to conclusion, while God's infinite awareness of all
propositions is based on pure intuition . . . The Divine intellect
grasps through the pure apprehension of its essence without
any discourse in time all the infinite properties, which are then
virtually implied in the definition of all things and which
finally, since they are infinite, are, in the Divine mind, perhaps
only in one essence.

GALILEO[1]

What is art? This is a question that cannot be answered in the
same way as one can answer the question: what is a table, what
is science, or what is philosophy? There is, strictly speaking,
no functionalism or extraneous finality in art. Art is not a
means to an end; it is its own finality; therefore it can be only
tentatively defined analogically, and through the more or less
agreed attributes that pertain to it. This being so, and the
concept of art not being reducible to a sentence carrying its
essential meaning, one is compelled to grope for a variety of
attributes, or for analogies and similes that could convey some
of this meaning. One could begin by saying that the object we
call an art object or an artefact is a construct, something
concrete, made up of wood, stone, pigments, musical notes or
words, provided, of course, that one bears in mind the vital
point that it is neither a construct that has been brought
together in response to a concept — something which would
imply purely utilitarian ends — nor a linguistic transaction
carried out in language used merely as a set of signs to convey
a clear-cut meaning, and therefore having no other aim

24

except that of conveying meaning and then disappearing or ceasing to exist once this meaning has been conveyed (such is the everyday use of language as money handed over in return for goods, or as food which, once consumed and digested, produces mental and physical energy).

Paintings, sculptures, musical compositions and even poems are very often commissioned by patrons, but once the commission has been accepted, the artist is left entirely free to fulfil his assignment, according to the laws of his art and his sensibility. A Picasso portrait is the sitter as seen by Picasso, and not a photograph of the sitter. The Popes who employed Michelangelo could not make him do what he did not wish to do; he served them, but he did so with his unsubdued pride, and according to the light of his genius. The material or the subject that an artist deals with cannot be looked upon as dead matter to be used in order to achieve a given end or to fashion a given object; it must be looked upon as living matter, whose form or essence must blend with the subjectivity of the artist, seeking to uncover and to reveal an aspect of the truth, through a construct or entity in which every aspect of the material and the subject has been transformed by him so as to express the marriage of knower and object as universalised, objectified subjectivity. Michelangelo extracts his famous *Captives* from the living marble; Rodin's Balzac half emerges as a mythical, elemental figure from the breast of the earth, a breast which genius feeds upon and lives on, ceaselessly lulled by the recurring tides of time. The activity, the shaping force or creativity that presides over these operations is always, in an indescribable way, disinterested, pleasurable and, in varying degrees, communicable. It is essentially non-utilitarian and non-conceptual and it aims at creating a coherent entity that is above all beautiful and true to its form, the beautiful including other normative attributes, such as the noble and the sublime.

The beauty of a work of art is neither the beauty of a natural landscape, nor that of a woman, though both could be as inspiring as any work of art, in a different way. A beautiful landscape or a beautiful woman is not the primary interest of the painter or the poet. First and foremost, a painter loves painting, and a poet loves poetry and writing poetry. A

25

beautiful landscape in painting is a beautiful painting and not a beautiful landscape; in the same way, Rembrandt's self-portraits are beautiful paintings of an 'unbeautiful face'. The beauty of a work of art is the beauty of something that is both real and unreal, transient — that is to say confined to the duration lived when one is in front of it — and timeless like Keats's Grecian urn or Yeats's eternal beauty as suggested in his poem *Byzantium*:

> Miracle, bird or golden handiwork,
> More miracle than bird or handiwork,
> Planted on the star-lit golden bough,
> Can like the cocks of Hades crow,
> Or, by the moon embittered, scorn aloud
> In glory of changeless metal
> Common bird or petal
> And all complexities of mire and blood.

One might dream all the dreams of a lifetime in front of the *Maya Desnuda* of Goya, but one has no hope of ever being transformed by the warmth of her skin or the glow of her eyes. The glow and pleasure thus experienced are purely mental; they are only dreams of pleasure, yet of course they are more lasting, more transforming than the kinetic pleasures of the senses, for they pertain to an immanent whole created by mind and endlessly apprehensible by mind. If the dreams this painting calls forth were of a kinetic nature, then it would be a bad painting; it would be a suggestive painting, a painting in which the painter has indulged, or has been unable to transmute, his purely physical reactions. The beauty of a work of art is primarily detached from the real, though it is an emanation of the real; it is disinterested, it is not directly connected with one's passions, instincts or beliefs. The work of art is an object on its own, from the contemplation or apprehension of which one may derive an awareness of perennial truth and an enriching experience. It cannot therefore be reduced to a real, physically graspable object; it can be grasped only through receptive imagination questing for truth. The work of art is not perceived as an object, the qualities of which are verifiable by the senses; yet it is not an emanation of fancy, which pays no attention to verisimilitude or to natural laws;

26

neither is it a copy of phenomenal reality. The work of art is a world in itself, rooted in reality, expressing transmuted reality, and yet transcending it; therefore it must be judged not by the standards that apply to reality and everyday life, but by the standards that apply to art.

The feelings, the emotions involved in art are aesthetic emotions, that is to say emotions and feelings transmuted by memory and by the imagination into an integral part of an imaginative creation. If a work of art provokes direct, kinetic reactions, then it must lack coherence and harmony in its parts, and it must be flawed by some conceptual notion that has assumed the ascendancy; in this case, one is confronted not with a work of art, but with a means to an end. If a painting excites real anger or lust, for instance, the artist has exteriorised his own feelings and imposed a certain amount of conceptualisation on the structure and on the coherence of the parts. In a similar way, a truly beautiful artistic nude should have no pornographic suggestions or connotations; if it has any, the creative artist has willed it so, as self-indulgence, or as part of preoccupations—commercial or other—that are alien to art.

A utilitarian object cannot be turned into a work of art by being given a label, a coat of paint or a place in a painting. It remains a concrete object, that is to say a sore thumb stuck on a canvas, and a canvas is not meant to have an object stuck on it, unless this object, like a piece of collage, is really part of the coherence of the painting. Such a coherence cannot be easily obtained if one tries to bring together materials of different natures that have not been fused into a whole as the embodiment and expression of the living experience of the artist at the moment when this whole was created. In a poem, the printed word 'stone' could not, for instance, be replaced by a real stone, nor the word 'glass' by real glass. A poem is a construct of words and not a painting made up of words used as monochrome pigments upon a page. All the possible fanciful arrangements of words upon a page will not make a poem unless the words have been fused into oneness as the expression of a unified imaginative experience. The rest is gimmickry and part of the acrobatics of our age trying to turn a widespread artistic itch and exhibitionism into so-called art.

A canvas, whether it is totally covered with manufactured objects or with one single colour, or left entirely blank, is not a work of art, but a mere statement of feelings or attitude. It might have some purely biographical or curiosity interest, if the person responsible for it is an important artist, but it can have no aesthetic value whatsoever. Mallarmé experienced all too well the horror of 'the white page', but he also knew that he had to put on it some signs and words in order to guide the reader's imagination towards the notion he wished him to apprehend, that 'un coup de dés jamais n'abolira le hasard'. Art is a coherent imaginative representation of a given aspect of life, or a symbolic entity embodying more or less universal aspects of truth. If it were not so, all black or blank canvases would be paintings, and all white pages would be poems. Duchamp's famous urinal is not a work of art, it is merely an object belonging to a type that can be repeated *ad libitum*. Duchamp's signature in no way individualises it, for anyone could possess a similar one, and Duchamp could put his signature on any number of similar ones, or those of another type, without ever establishing with any of them any other relationship than that of ownership. The signature is merely a label, a sign, which cannot indicate any organic relationship between owner and object, simply because the object in question is not unique, as is the work of art.

Art can be reduced neither to purely physical properties nor to purely mental representations. The notion that a poem of any substantial length, a painting or symphony can be composed in its entirety and held in the mind is not tenable (it is possible that Mozart may provide an exception to this). Although Beethoven became deaf, there is no reason to believe that he composed symphonies in their entirety in his head. He heard them in his head, like any creative artist, but he wrote them down according to the flow of his inspiration, and modified them on the page. A given line, a given rhythm inspired by God knows what, could be, and often is, the starting element of a poem or a musical composition, but the rest, as Valéry said, has to be obtained through sustained attention and hard work. Poetry is indeed above all music, and is so even in its dramatic form. The words on the page are never enough. The ear, both the outer and the inner ear,

matters more than the eye, and a poem must not only be read but also heard mentally or by the outer ear. The basic artistic emotion, whatever the art may be, is above all of a musical nature; it manifests itself first as a kind of music or rhythm, before one is aware of what it truly is; this initial, basic rhythm lies at the root of the poem or of any artistic composition. Whatever it is, it is this essential rhythm which decides whether the composition will be joyful, sad, directly lyrical or complex.

Schiller said: 'With me, emotion is at the beginning, without any definite ideas. Those ideas do not arise until later on. A certain musical disposition of mind comes first, and after follow the poetical ideas.' In so saying, he was merely following Plato, and anticipating the great upholder of the pre-eminence of music in the arts — Schopenhauer. After him, from Wagner to Nietzsche, Pater, Mallarmé and Valéry, most artists acknowledge the primacy of music in artistic composition. 'Music is distinguished from all the arts by the fact that it is not a copy of the phenomenon, or more accurately the adequate objectivity of the will, but is the direct copy of the will itself and therefore represents the metaphysical of everything physical in the world, and the thing-in-itself of every phenomenon.' (Schopenhauer, *The World as Will*)[2]. Music expresses best the fundamental structure and root of art. Colours have irrational powers and, like dreams, they defy reason; these powers can be suggested only by music or analogies with music. The testimony of Delacroix, a contemporary of Wagner, Pater, Baudelaire, Verlaine and Mallarmé, for whom music was the criterion of the arts, sums up this point: 'The pleasure derived from a painting is completely different from that derived from a literary work. There is a kind of emotion which pertains to painting only; nothing else can suggest it . . . It is what could be described as the music of a painting. Before knowing what a given painting represents, one enters a cathedral, and one finds oneself placed at a distance which is too great for one to know what this painting represents, and often one finds oneself caught in its magic harmony.'[3]

The very essence of being, as it translates itself in artistic experience and creation, is music, which imposes the

dominant colour, the rhythm or affective tone of any work of art. Once this rhythm has unlocked the creative impulse, the impulse becomes involved in all sorts of dialectical processes of images, colours and gestures, and in the organic life of the material, all of which cause the final outcome of its development to be unpredictable and unknowable, until the creative process has exhausted itself through achieving a final phenomenal appearance or shape.

Admittedly, some kind of music, in the Schopenhauerian meaning of music as will, may trigger off the creative impulse, and can take it part of the way; but art cannot be considered in terms of a purely mental representation; on the contrary, on the whole it requires embodiment in material — words, musical notes, colours, stone, marble, iron or other material. A painting may float or even acquire a definite clear shape in the mind of the painter, but this is merely an image or a vague vision of what the painting could be. When it comes to the act of translating this vision into colours and volumes, that is to say the act of capturing and fixing through them the experience that the painter seeks to elicit from himself, so as to know what it is and to make it possible for others both to know it and also to know something of themselves, the problem is different. The images that are in the mind are one thing, the images that have to be brought to life on a canvas are another. The life of the imagination is both clear-cut in its outlines and also boundless; it is synchronic, unaware of the laws of perspective, and more amenable to all sorts of harmonisations than the tensions and conflicts of the canvas in which each colour has to fight for its own life and space. The articulation of images on a canvas carries with it problems that the imagination had not, and could not, have anticipated, and that not only have to be solved, but necessarily bring with them other unforeseen problems. So the painter may know where he begins, but he certainly does not know where he will end or what exactly he was trying to do until he has actually done it.

A creative artist may compose a small part of his work in his head, but that is only a beginning. What matters is the act of giving shape to the whole thing, and a few words or even a stanza are not a whole poem, any more than a few bars of

music are a symphony. The mental work is merely a starting point. The passage from imagination to reality brings into play the material used and its laws, which impose their own constrictions on the creative mind. An artist may dream of an Apollonian shape, but the end product of his efforts may be totally different. Every chisel stroke on sculpture, every brush stroke on a canvas, every word put down on a page, modifies the preceding one, adds to or detracts from the already achieved meaning, for it is the pursuit of the ideal wholeness of the work that dictates the changes and the handling of the details, until the concrete phenomenal wholeness obtained corresponds to the vision the artist has of it. The vision of the whole does not exist in the artist's mind, it grows with the work, for, while he works, this vision progressively emerges and only reaches its full development at the end of his efforts. In art there is no foreseeing the end product, or the future, for if it were so, one would fall into conceptualism — which is not art but exposition or explanation; there is only the doing, and of course there is the discovery and knowing through doing.

Imagination is the mental activity through which ideas, not concepts, are brought together through words, musical notes or pigments or other material, and given an existential shape in symbolic, organic entities embodying more or less universal meanings. The poet or the thinker is a human being whose imagination can crystallise the invisible and the unseen in words. He does not clothe in words some already existing notion; he makes with words, in the same way as the composer makes with musical notes and the painter and sculptor with pigments, stone, metal or wood. Wordsworth's notion that there are many poets who have 'The vision and the faculty divine, Yet wanting the accomplishment of verse', as if verbal skill were an additional faculty to the purely poetic gift, is not tenable. There is no poetry without expression, and the poet only knows himself as a poet, not through his sensibility, feelings or emotions as a man, but through their crystallisation in words, each active in relation to the others so as to create an organic, living entity. To be a painter or a sculptor is not to be able to dream of paintings or sculptures, but to be born with the capacity of creating life through one's hands;

31

if this perfect organic link between imagination and hands is not present, one has no hope of being a painter or a sculptor. On the other hand, one can be a good craftsman without being a sculptor, and a good draughtsman without being a painter. What is missing in both cases is the imagination that makes things new. A good craftsman can copy, or imitate, but unless he has the imagination to express and universalise the changing truth of his experience, he remains a craftsman who repeats or elaborates a certain pattern.

The poet does not, on the whole, wilfully set out to write a poem; he is generally impelled to do so by the emotional pressure of something wanting to be born, or by a vision of what this something that haunts him might be. He may not succeed in grasping this vision at his first attempt, he may never succeed in finding out what he vaguely hoped to find, yet he will go on trying, until he realises that, as far as he is concerned, he can go no further. Once he has emerged from his trance-like state, from the haze of his pursuit, and when he contemplates in the broad daylight of his conscious mind the point he has reached, the work that he has done, he can, vaguely remembering the vision that guided him, consciously attempt to complete what he has failed to achieve in the course of his entranced pursuit. Yet, though he may be able to contribute notable improvements here and there, he will not be able to recapture 'the glory and the dream', or the Coleridgean inspiration which the person from Porlock unfortunately dispelled, and in the end he will have to make do with what he has been able to achieve. A poet does not need to have experienced all the emotions that he describes; what matters is his capacity to live them imaginatively. The knowledge of the way things are made and the way they work is more important than the things themselves, for it implies their mastery, and it adds to them a dimension that they do not possess: that of human consciousness.

An artist slowly develops for his own usage his own language and style, progressively evolving in himself a blend of his inner feelings, thoughts and rhythms, together with the images, the metaphors and the style that will express them. He does that through every moment of his life, at the conscious and subconscious level, until the pressure of experience is such that it

must cohere in a symbolic entity or object that is on a duration with his own consciousness or spiritual life, which continuously makes itself through moments that transcend time. An artist's vision and style are necessarily conditioned by the vision and style of those who preceded him. Cézanne and Baudelaire, for instance, are in this respect as much conditioned by the painters and poets who came before them as by the historico-social background of their time. But Baudelaire no more wanted to be Victor Hugo than Valéry wanted to be Baudelaire. Each wanted to be himself, though fully aware of his predecessors. Cézanne did not propose to imitate Poussin, but to 'refaire Poussin d'après nature'. Picasso did not imitate Velasquez; he sought to wrestle out of his rendering of *Las Meninas* the secrets of his own subjectivity.

An artist, said Baudelaire, depends on nobody but himself and he dies childless, having been his own king, his own priest, his own god. An artist learns more from art than from nature, and he generally imitates art, not nature; he never copies nature; he essentialises it and abstracts from it, and he uses it as a source from which he weaves his 'unnatural' creations. Realism in art does not mean submission to, or imitation of, phenomenal reality, but the expression of a reality that corresponds to the historico-social and affective reality of the time in which the artist lives, and that has therefore its own history-bound way of revealing and expressing its infra-structures through art. True realism is change and trans-formation, not so much in the representation as in the imaginative structuring of reality, which is fully alive, both as a whole and in its component parts. Realism implies a living and therefore immanent reality, with or without an under-lying transcendence, while materialism possesses no other life except that conferred upon it by the human.

Perceptions always bear the imprint of the mind and sensibility of the perceiver. They are made by the mind energised by sense-data, and in the end one sees only what one looks at, and what one wants to see, and one only understands or fully grasps the answers to the questions one asks oneself. One does not choose one's love, one's model or, least of all, God Himself; one is chosen, called, overwhelmed by irre-sistible affinities and fascinations. The artist is an Æolian

33

harp catching up the slightest whispers and sighs of his age and of times beyond it, and the songs that he records, the incarnations that he produces are valid for all times. Every age has its dominant sensibility and consequently its own style; as sensibility changes, so does style, which imposes shape and meaning upon human experience. Therefore the artist must always express today's feelings with today's voice, and not with the voice or style of yesterday, otherwise the discrepancy between the two will make true meaning impossible. As for tomorrow's style, it can only be born at the same time as the voice that will modulate or express it, therefore it cannot be truly said that so-and-so has produced a style that is 'in advance of his age'; body and soul go together, are parts of one another and form a whole that only lovers of mental gymnastics seek in vain to manipulate as totally separate entities. The world exhibits in all its aspects, at the microscopic and the macroscopic level, wholeness and continuity.

An artist of genius is not a throw of God's dice, he is part of a continuity that spans history, and continuously gives it a new or slightly new face, through the fact that every work of art transforms and adds to the meaning of life, and transmutes the art that preceded it so as to make possible a new style. The past has to be constantly readjusted and reassessed in the light of the present, and this Heraclitean change or flux will go on until the end of time. Man is both an individuate being, that is to say a fragment of multiplicity, and also part of the One in which perfection and truth reside. Every artist is haunted by what has already been done by others, by achievements that he seeks to emulate and to transcend through creations that are entirely his own until they become everyone else's sources of inspiration, and also repudiations, for an artist always seeks to repudiate and to transform what preceded him. In order to do so, he has to be deeply and extensively aware of what preceded him; only thus will he know who he should try to be, if he really wishes to be both truly himself and also part of the great self or intersubjectivity that enfolds all art.

The modern concern with the present only is not art, but emotionalism without style or profundity. The poetry of a poet who writes without the awareness of the great poets who preceded him is merely sentimental effusion and an expression

of his own personality, with little relation to the necessary schematisation and distance from life that art requires. The true artist does not reject the past, whose living substance he needs; he merely rejects superficial appearances and academism, which is the natural final phase of any living art, and which therefore must be rejected by the age of those who did not foster it. To write or to paint as if no one had ever written or painted before requires a knowledge of what has been done before, otherwise what might look like newly-minted creations could very well be only pale imitations of already existing masterpieces. To make new, it is necessary to be aware of what already is.

The true artist does not imitate; he is far too concerned with his own voice and his own essence; he only takes what he needs in order to be himself and to express his vision or his truth. The truth for the artist is his work; through it he resolves his inner quarrels, his disharmonies and discontents, both with himself and with the world, in the harmony and joy of creation. It is only through the mastery of a style entirely his own that he can achieve the freedom of being nothing but his own making. Every creation is both a freedom and a birth that becomes part of the timeless life of art. Whether the *Mona Lisa* is the portrait of a woman Leonardo knew or the idealised picture of a woman does not matter, and is something that cannot be decided. Whatever the existential reality behind it, its timeless artistic reality is the very aim of life itself, through art's transmutations or through the transcendence of goodness and truth.

The main task of genius consists in creating imaginative lives that are representative of its age and of humankind in general, and that are perfectly detached from the life and personality of their creator, whose imagination feeds upon life and transforms everything into fruits in which the component elements are as unrecognisable as manure is from the scent of the rose. They are the visions of a man who, with his feet on the earth, gazes through the prism of his imagination at inchoate forms that take concrete shape on a screen of clouds miles away beyond the reach of perceptions' criteria, reflecting the conflicts, thoughts and tensions that, below them on earth, are the forces that mould the life of men. The capacity to see

things from above or to X-ray them so as to obtain a unified system is the mark of genius. It indicates a structural relationship between an individuate imagination and beliefs, thoughts and tensions that, grasped through this individuate imagination, are fused into mental systems that express the dominant forces of a given moment of history and are in a constant state of flux. These systems change according to historical conditions; they break up and continuously re-form in patterns that in the end can only oscillate between two main poles — that of transcendence and that of immanence. These poles can be apart or even opposites (as is the case with negated transcendence and anthropomorphic immanence from the end of the nineteenth century onwards), or linked together, as in the great religious moments of history, when man and the universe are integrated and therefore animated with the awareness of a unified causality and finality.

'The goal of art,' said Aristotle, 'is to suggest the hidden meaning of things, and not their appearance; for this profound truth contains the true reality of things, which is not conveyed by their appearance.' Art is not cerebration, it is action; it is not a pastime, a way of wearing the hours away in order to avoid boredom, or the Pascalian solitude of a lonely room. It is the essence of man seeking to emerge from the contingent and the finite, necessarily implying, at its core, an imaginative emotional experience involving the whole being of the creative mind, whether this experience is the death of a friend — the death of Hallam for Tennyson — or the sublime vision of the Alps that so deeply affected both Coleridge and Turner. Such experience manifests its own form, which corresponds to the emotional rhythm and the imaginative force that underlie it, and which, once it has reached phenomenal appearance, reveals an aspect of the true essence of the creator, a moment of truth or self-knowledge, and knowledge for him as well as for all those who apprehend it. This ability to reach essence or being is not given to many, and man attains it only when, as saint or genius, he discovers and expresses the being of creation and therefore connects with Being.

Genius, whether in action, philosophy or the arts, is measured by its capacity to crystallise and express the dynamic

36

forces of the time to which it belongs. These forces may be apparent or more or less submerged by fashionable, superficial currents, which are of little permanent value, but which nevertheless give the impression of being the real dynamic forces of society. The truly dynamic forces loom on the horizon, only apprehensible to the man of genius who, by revealing them, brings them into consciousness, and thus hastens their coming to life and their recognition by all. This recognition of the dominant and history-making forces of an epoch may be slow, and the complete evolution of certain vital ideas and forces may be necessary before their importance is fully accepted. Churchill and De Gaulle had to wait for the dismemberment of Czechoslovakia and the collapse of France before their vision of their age was endorsed by the bulk of their fellow-countrymen. Cézanne had to wait for a long time before the inhabitants of his native town, and the many others who despised him when he was alive, came to recognise their mistake.

Sometimes, the light cast by genius is such that those around it can grasp neither its source nor the reality of the truth that it reveals; they apprehend the appearance without the substance, and they turn this appearance into empty patterns, or into a style that they repeat, in the belief, shared by the bulk of their contemporaries, that they are expressing vital truths which shape their lives as well as the life of mankind. Then art, whether it is poetry, painting or sculpture, is usually nothing but empty appearance without style or substance, and of course the more shallow it is, the more widely it seems to be appreciated. The same can also apply to philosophy. Forgetting the seminal source from which it started, the would-be philosopher can drift all too easily into superficial formulae of knowledge, or into a style of philosophising that vaguely imitates the original mind that gave birth to the philosophy, but has no real connections with the force that informed it and related it to life itself.

A cursory glance at history makes it clear that artistic genius is not associated with fragmentations and with the cult of appearances, and that it flourishes best in periods that possess a spiritual centre of some sort, a characteristic style and criteria of values to which all aspects of art can be referred.

In an age which possesses neither a style nor a spiritual centre, art and its appreciation partake of the same anarchic, iconoclastic climate, becoming reduced to expressions and self-gratifications of the individual ego. Most people agree that morality and moral judgments rest upon principles, norms and values that are rational or rationalisable, and that are valid not only for the society that evolved them but also for other societies that accept them either in part or as a whole. The problem is different with art and its appreciation, about which the widespread belief seems to be that any view is as good as another. One can grant that both art and its appreciation are essentially subjective activities, yet art is a manifestation of reason and is, in its domain and within its accepted canons, as rational as science. The important point lies, of course, in the definition given to 'reason' and to 'rational'. If one reduces reason to the understanding, and to the handling of concepts, then art is, as has so often been glibly stated, irrational. If, on the other hand, reason includes, as it should, intuition and imagination, then art is as rational and as exacting and precise in its composition as any piece of scientific research. If the appreciation of art takes place at the purely phenomenal level, at the level of appearance, simple resemblance to reality or superficial satisfaction of the senses, then this type of appreciation is, no doubt, purely individual or personal. But if one admits the premise that the excellence of a work of art implies the fulfilment of certain canons and norms, then it is rational to believe that the critic or the assessor of a work of art must endeavour to find out if these accepted canons and principles have been partially or fully satisfied, and to what extent they have been integrated in the harmony of the work of art. These conclusions seem to me to be applicable to all works of art.

A play must be a coherence of component elements, a harmony of conflicting forces finding in it their resolution. If the characters are a matter of black and white, or are only mouthpieces for certain aspects of human or social passions and grievances, then the play lacks balance, and it cannot come anywhere near the level of achievement necessary to make of it a good play, let alone a masterpiece. The same is true for painting and sculpture. A self-portrait of Rembrandt

exhibits the same harmony of component elements, the same equilibrium of tensions, of light and shade, of masses, spaces and movement that can be found in the *Mona Lisa*, in *The Burghers of Calais* of Rodin, or in Michelangelo's *Pietà*. Rembrandt reaches the universal, the intersubjective, through his intense probing of all the aspects of the natural and the real, as apprehended by the senses. His self-portraits rise from the canvas in an appearance of perfect and total reality, which reveals the mystery of being through the texture, light and shade of the human face. The *Mona Lisa* starts from the phenomenal appearance, and each detail is woven into a coherence which is timeless. It is both one woman and the feminine itself, with its mystery, its strength, its necessity for life, all fused together in a perfect blend of reality and imagination. The features, the pose, the mysterious spirituality of the face harmonise with the imprecise fluidity of the landscape which, of course, is of the earth and yet seems to belong to no specific time or place. It is art *sub specie aeternitatis*. Rodin's naturalistic realism in *The Burghers of Calais* contrasts with the blend of realism and timelessness of Michelangelo's *Pietà*, in which the realistically portrayed affliction of Christ's face and broken body perfectly merges into the tragic sense of suffering and timelessness of the Virgin who strenuously raises him and lifts him out of the earth, yet with the earth, as a link between earth and Heaven. With Michelangelo, the journey from the idealised Greek body, impervious to suffering, to the Christian body as the dwelling of the soul, and therefore as the image of the incarnation, has finally been completed.

The plays of Aeschylus, Sophocles and Shakespeare all partake of certain vital traits of composition, orchestration and harmony that can be easily ascertained. Oedipus could no more be made happy than King Lear be made to spend his old age as a fond father and grandfather with his daughter Cordelia and her children. The forces unleashed by folly or by fate can be assuaged only by death, which restores the equilibrium of the moral universe to which these characters belong. Rembrandt's *Night Watch* could not afford to have a dancer or a clown as one of its characters without destroying the equilibrium of the painting. Such an equilibrium is obviously

part of an imaginative, rational order that the onlooker or the reader, whatever his individual sensibility and mental make-up, must recognise and take into account in any attempt to appreciate these works. He may prefer certain poets, painters or dramatists to others, if he has to make a choice, but he cannot fail to be aware of the fact that all artistic masterpieces or accomplished works of art exhibit certain basic traits that are part of the rationality of any creation. Ockham's principle: *Pluritas non est ponanda sine necessitate* is nowhere more true than in art. Just as in the construction of a Roman vault every stone used is necessary and fits perfectly with those that surround it, so in the same way in art every component element ought to be necessary and to fit perfectly within the harmony of the whole. Coherence is harmony, and beauty itself is conformity with a perfection of lines, volumes, colours or Pythagorean numbers, expressing the absolute rationality of the universe that Greek or Renaissance man sought to embody in the arts. The outstanding embodiment of this conception is Leonardo, artist and scientist, part of an age of great discoveries and of wider and wider horizons, illumined by reason. Every artist has, of course, his own structures, patterns, volumes and colours, which he uses in order to achieve coherence. For instance, the coherence of Rubens with his billowing lines and richly coloured spheres, whether they represent fruits or human curves, is not that of Rembrandt's startling contrasts between light and darkness — meeting points of time and Eternity; but they both partake of the same rational, organic logic, which is the essence of creation.

To reproduce exactly or to copy a face, and to concentrate upon the features that express its inner life or essence, are two very different things. The appearance must be the appearance of the essential form, and the task of the painter consists in discovering the essential beyond the appearance and in giving it phenomenal life. To depict the soul or inner life of the sitter, whoever he is, is the only true task of the painter. A portrait, like any other work done by an artist, can be a work of art only if it expresses a fully integrated, living subjectivity. Therefore all its component elements must be coherent and attuned to the organic life of the whole, part of it and feeding on it, just as any newly born organism feeds upon its source.

40

If the equilibrium of the component parts is not preserved, if one element is given undue pre-eminence over the others in a way that throws them out of balance, and is obviously in conflict with the universal aspiration of nature and reason towards order, then it is evident that the artist has succumbed to some conceptual temptation that has prevented him from allowing the true essences of the material and of the themes that he was handling to coalesce and to equilibrate themselves into a harmonious whole. Whatever the domain of art, the spiritual structure of the work must assert its pre-eminence over its respective component elements and material, and must therefore adjust and shape them so as to convey and render apprehensible its own organic life. This is the work of the imagination.

Creative imagination is purposive imagination. It has nothing to do with idle, day-dreaming fancy which allows the mind to free-wheel without any sustained relationship with reality. The work of art does not translate the creator's state of mind, for the creator only knows what he himself was, and what he was after, once he has completed his work. In fact, it is not the creator who makes the work; it is the work that makes him what he is and enables him to go on making himself through it. The knowledge he thus acquires is always temporary and always knowledge of his past, a kind of backward glance, like that of Orpheus seeking in vain to know Eurydice who, as soon as he turns round, fades away in the mist of the Acheron. The temporariness of this knowledge is such that the poet or the painter may not be able to recognise his true self in some poems or paintings of his youth. Picasso's 'Raphael period' never recurred. The changing experiences of life change both the content and the appearance — which are inseparable — of the work of the creative artist. The Picasso who painted *Les Demoiselles d'Avignon* could have nothing more to do with the Picasso of the 'blue period' and of the Raphael-like skill in drawing; he was on the move towards Cubism, *Guernica* and his shattering compositions of the 1939 war and the immediate post-war years.

The artist is in essence a seeker after truth, and the truth that he reveals is different from scientific truth, though no less important, and very often anticipates it. Art exhibits the

unfolding of the changing aspects of the forms or ideas that animate man through time. Every living thing has a form which is both its cause and its finality. This principle necessarily applies to creation itself, and art helps us to know what it is, and so to contribute to its fulfilment, which, since the form or essence of life consists in exhibiting itself through appearing, can only be self-knowledge. The greater the artist, the more capable he is of grasping and exhibiting the main forces at work in the growth of mankind. These, like all natural forces, contain the negative and the positive, the good and the bad, but it is obvious that just as the negative or non-being is only an attribute of the positive or of being, and not an entity, in the same way the bad, or what is also called evil, is only an attribute or a dialectical aspect of the unfolding of the good or of being that must in the end prevail, as it always does in truly great art; for in the end one can say: 'in thy will is our peace', or: 'Ripeness is all.'

Being, pure goodness, enfolds being and non-being or the nothingness of human evil. The Sophoclean conflicts of the most basic natural forces and laws — brotherly love and the respect of the Law — are resolved by the intervention of divine justice, which confers numinous powers upon Oedipus's burial place. Oedipus, the greatest archetype of the Greek stage, a compound of suffering and wisdom, is destined to exercise a lasting, beneficent influence upon mankind, by virtue of his life-long afflictions and his tragic death. He is a kind of redeemer, and his shrine will be, like Calvary, a place of pilgrimage and moral healing. After the trials and suffering imposed on him by the gods, he reaches a kind of transcendental serenity, fount of comfort and illumination for others. His earthly torments seem to be, as is so often the case in religion, the necessary dialectical counterpart of his transfiguration, which is apparently in some ways a prefiguration of the Christian pattern of redemption, which is also the natural pattern of earthly wisdom.

Christian thought divides the superman or the incarnation of the Divine into two — Lucifer, the fallen angel and corrupter of God's creation, and Christ, the redeemer and mediator between finite beings and Being. In the Greek world the superman is one, and the cosmic struggle between good and

evil takes place in himself, with the gods as protagonists and final judges. Prometheus, revealer of fire to man, therefore betrayer of the gods, and Oedipus, transgressor of the most sacred laws of nature, raise themselves to the level of the gods, and once they have, through suffering and sorrow, paid the price that goes with their defiance of the Law, they compel the gods' justice and the granting to themselves of numinous power. Shakespearian tragedy, like Sophoclean tragedy, does not rest upon the notion that 'man is a useless passion', in an absurd universe. The why, whence and where of creation may be mysterious and beyond the human understanding, but creation testifies to an order and to laws that must be respected, and Shakespeare's genius, attuned to the universal, exhibits evil and tragic suffering, not as gratuitous or hopeless aspects of the human condition, but as painful stations on the way towards the emergence of an accepted and welcome moral order, which is the law of the universe. The wanton death of Desdemona and the tragic suicide of Othello call forth not despondency or hopelessness, but heart-breaking sorrow at the thought that such nobility and innocence can so cruelly be undone by credulity and jealousy. Neither Hamlet nor Lear dies in despair. They both die in a world of reconciliation and continuity in which suffering and death, though incomprehensible, are accepted as part of the true meaning of being. Whether in Greece or in Elizabethan England, tragedy leaves us with the ultimate feeling that, despite suffering, death and all sorts of phenomenal changes, life is indestructibly positive, and part of the perenniality of Being.

Art is inherent in man's nature. It is a way by which he can know himself as an individual and as part of mankind. It is, like thought, a manifestation of Being; it expresses, or rather it suggests, a reality that can be neither perceived nor objectified, but that can be apprehended only through imagination, as being other than what it appears to be. Science is concerned with the exact workings and the description of what is, according to the logical terms of its method, which rests upon calculation and verification according to a reality that is itself indefinable in its essence. The truth of art rests not upon calculation and logic, but upon the emergence, through the receptive imagination of the artist, of the truth of Being and

43

its embodiment in a coherence achieved according to a methodology of construction as exacting as any scientific method.

God's creation is not an act of withdrawal and diminution, but an explosion of joy into the endless manifestations of Being, illuminating itself and knowing itself through them. The discovery of the true nature of things and experiences, the giving of a shape to forms that have their roots in the uncreated and in nothingness, is an act of spiritual fulfilment that unites human subjectivity and time. The outcome of the creative act, whether it is Dante's journey through Hell and Purgatory or that of Michelangelo reliving in his imagination the agony and transfiguration of Mother-mankind, is a form of indescribable joy that lifts the creative subject into the objectivity and anonymousness of the whole. However narrow and dark the journey, and whatever the travails involved and transcended, creation — the birth of truth — is joyous. Coleridge's *Ode to Dejection*, deploring the loss of joy through the loss of creativity, brings him joy, the joy of singing his sorrows and thus of turning them into perennial truths. It is the same for Wordsworth's *Ode on Intimations of Immortality*:

> 'Whither is fled the visionary gleam?
> Where is it now, the glory and the dream?'

It is the same for hymns and elegies and tragedies that bring to the creator the metaphysical joy of associating his inner self with the music and mystery of the universe. Hamlet and Lear, for instance, are neither sad nor overwhelmed by hopelessness and nihilism; each of them is haunted by his anti-self, his non-essence or non-truth, which, through trials and errors, he must resorb, so as to reach his truth, the truth that will enable him to commune with Being. They both die on the threshold of illumination, with Being in sight, and their deaths are not a leap into nothingness but a winging up towards light and eternal joy. Blind Oedipus, no more blind than two-eyed, distraught Lear, finally emerges from the womb of his night into a dawn which marks the birth of his eternal life. The creative mind is always homeward bent, towards the shores of its original birth, which it relives through every one of its creations — the footsteps of transcendence and

44

source of peace beyond the understanding.

Art is essentially the return or the restitution of individuate objects or experiences to the whole, to which they belong in the same way as a plant belongs to the earth from which it has sprung and a child belongs to the womb that has given him life and nursed his growth. The everlasting mother of art is being, and art is a return, through the mediation of the artist, of all the individuations of being to Being. The artefact is a mirror through which the artist and the onlooker become conscious of their own true feelings and thoughts. Art is therefore self-knowledge, both for the one who practises it and for the one who apprehends it; it is the dream that haunts man's life, the nostalgia of Eternity and of worlds beyond the human reach. Just as Greek heroes born from unions between mortals and immortals were partially immortal, the work of art, born from the marriage of the finite with the infinite, carries about it an aura of immortality which, though it is not absolute, will last at least as long as man. Man is only man as a creative being, living both in his own creative time, during which he communes with Eternity, and as a part of the time and society in which he exists and which he expresses. Thus he lives in a time that is both time and a transcendence of time, or a spark of Eternity incarnate in time through the human imagination.

3

The Perenniality of Art

Thus when the artificer of any object reproduces its essence and
virtue by keeping his gaze fixed upon what is self-consistent and
using it as a model, the object thus executed is necessarily
altogether beautiful. But if he looks towards the world of
becoming and uses a created model, the result is not beautiful.

PLATO[1]

From the moment man awoke to consciousness through
language and thought, he became an artist, a maker, who,
out of the nothingness of night, created mediatory images of
truths that illuminated the lives of his fellow men. The naming
of things for what they truly are by the poet, the establishing
of being through words, the controlling of the animal world
and of the forces of nature, through their images, make of art
and of the artist the founding elements of history and civilisa-
tion. The seizing of signs from the gods or from God is
part of the task of the artist as the mediator between spirit and
the natural world. As Hölderlin writes:

> Much has man learnt,
> Many of the heavenly ones has he named,
> Since we have been in conversation
> And have been able to hear from one another.
> . . .
>
> Yet it behoves us, under the storms of God,
> Ye poets! with uncovered head to stand,
> With our own hand to grasp the very lightning-flash
> Paternal, and to pass, wrapped in song,
> The divine gift to the people.[2]

46

The sculptors of the various megalithic monuments, the painters of Altamira, Lascaux and the Hoggar, Homer, the early lyrical poets of Greece and the Middle East preceded Aeschylus and Sophocles, the great pre-Socratic philosophers, Plato, Socrates and Aristotle, as well as the founders of religions from Buddha to Christ and Mohammed. Philosophers began to ask questions about Being, and great avatars of Being appeared, only when Being and its various aspects in creation had been brought to life or to the phenomenal world by the poetic mind of man, who gave a name or a shape to the being of things. The first words, the first images made by man, aimed at grasping and bringing to light the essence or truth of things, which is not their conformity with their mental representation or with their mental perception, but is their reality, that is to say what they truly are as part of Being, which alone can know them perfectly as part of its own unity and coherence. As far as man is concerned, things can be known only fragmentarily, in rare moments of apperception and illumination that are the privilege of the artist or the mystic. Illumination can take place only if there is receptivity towards it, so that the truth may emerge as it is, as the essence of things or beings, being free to reveal what they truly are. Such revelations cannot take place unless the creative being allows his own essence, his timeless and spaceless subjectivity, to stand naked so as to receive the essence of the thing or being with which he wishes to be united, and which he wishes to know as part of the knowing of his own subjectivity. There is thus an interpenetration of essences or subjectivities that are part of the intersubjectivity of Being, and this interpenetration can take place only in absolute freedom, and is, in fact, freedom itself.

Freedom is not a quality or a property that man possesses; freedom is the essence of things and of beings, and as such it is not wielded or controlled by man, it is what makes man; it is his truth, and this truth is above all revealed by art. Art is essence or truth in time, that is to say separated from the totality and perfection of Being, therefore the truth revealed is neither complete nor absolute. The aim of art is to reveal what is, as part of the whole, but the artist can have only glimpses of the whole; he cannot encompass it or know it; his

revelation always carries with it shadows, non-knowledge and non-truth, for it belongs to the finite, imperfect world of being and non-being. The artist always operates against a background of mystery or darkness from which he seeks, through his imagination and receptivity, to uncover the essence or truth of things, but he can do so only if he keeps strictly to his own inner laws and to the laws of his art, which rest upon the absolute freedom of the essences — the essence of man and that of things. Listening to any voice other than that of essence as freedom is fatal. The voice of morality, commonsense, the intellect, society, can have only a detrimental effect on art, which requires freedom. Whether in science or in art, truth is the uncovering of what is, as part of the whole which is creation.

All things have their own laws, and any attempt to modify them or to distort them is an attempt to deflect them from their own finality. An acorn is meant to become an oak and not an apple or a chestnut tree. An idea is true in itself, and in varying degrees valuable, if it is allowed to develop according to its inner law, and according to the inherent affinities of its component elements. If it cannot achieve maturation through the existential fulfilment that separates its positive from its negative aspects, it will go on living as part of human thought until its true maturation through existential activity has taken place. Ideas form the essentialised structure of spirit or transcendence, which knows itself progressively through the maturation of ideas that takes place through action in time — art and philosophy being aspects of action in as far as they confer upon ideas consciousness and light. An idea can reach maturation only in the right historical conditions; if they are not right, not adequate for its development, its maturation through action — political, artistic or philosophic — will be lacking in the total coherence and fullness that confer upon it existential reality and consequently, in its positive aspects, perenniality. If an idea has not reached maturation, it continues to exist as a spiritual force until it reaches its moment of final transformation through action. Ideas, of course, are not abstractions, nor are they vague notions purely confined to the intelligible world. They are the essences of reality, part of Mind, which unites individual

subjectivity to intersubjectivity, and manifests itself through individuate minds whose range is determined by the range and scope of the ideas they can enfold and reveal.

Plato's idea of the Idea—source of ideas—is Plato's idea and nobody else's; but it is not an abstraction without existential reality. Plato's idea is both something perennial, something pertaining to man as man, and something pertaining to a historical moment in time. Plato incarnated a moment in time when spiritual and phenomenal reality were in perfect equilibrium, the phenomenal being totally undisturbed by fears, longings or premonitions, and thus echoing in itself the perfection and serenity of the absolute. It was an extraordinary moment, in which 'those whom the gods loved died young' and rejoined them; it was the moment of Homeric heroes who still haunt our dreams, the moment of 'the nothing too much' which, if unheeded, led to Caucasian rocks or through trials to Athenian groves, the moment of the perfect equilibrium and radiant beauty of Greek art, a beauty that is all that the eye can see or the ear can hear, without any forebodings from an unintelligible world beyond human reason. The world was harmonious and just; the Parcae may have seemed to be unpredictable, and to cut the threads of human lives whenever it pleased them, but they themselves knew when to cut and when not to cut, and the sum total of their action was meant to lead to the maintenance of equilibrium and justice in the world. The violence, tensions, conflicts and violations of natural laws of the tragedies of Aeschylus and Sophocles found their final resolutions in the ideal of justice that was the main preoccupation of men as well as that of the purest incarnation of the gods, Minerva.

In the Greek world the spiritual forces that are incarnated in artistic creations, the sculptural or pictorial representations of the human body and the architecture which sometimes embodies them, exhibit a perfect balance between appearance and substance. Aphrodite is supremely beautiful, and nothing else; there is no suggestion that she is or can be anything else. She certainly is alive, but she is such that no one may dream of her; one knows that no man will ever live with her; she may have sympathies for Aeneas or Paris, but no mortal will share her couch. In her, the dream of beauty and reality are one;

the sculptor who shaped her body did not try to put into it more than the body could bear; he did not try to add to her features or her gaze something which may or may not be part of what happens in her heart or mind, or in his, for that matter. Her essence is to be beautiful. As for any attempt to make her body talk or to cram into her appearance a spirituality that is not perfectly absorbed in it and that therefore overflows and breaks the equilibrium between substance and appearance, this was left to seventeenth-century baroque and to Romantic art.

The nude in Greek art is neither hieratic nor abstract, and though it is both sensuous and alive, it shows none of the sexuality of Indian nudes. Its fluidity and movement contrast with the stiffness and symbolism of twenty-five centuries of Sumerian, Egyptian and Eastern art. The Greeks accepted, on the whole, the basic Protagorean principle that 'man is the measure of all things'. To which Plato replied: 'Nothing imperfect is the measure of anything'[3] and 'God is the measure of all things'.[4] In their world, immanent man is separated from transcendence or the Eternal, to which he will only return once he has shed 'the fury and the mire of human veins' and crossed the sea of life to reach the Isles of the Blessed, where he will live in company with the Golden Race, enjoying the music of the spheres and the vision of Eternity. This Platonic and neo-Platonic concept of man and of the universe pervaded Augustinianism and dominated Christian thought until the emergence of Thomistic existentialism. The Incarnation is the crux of Christianity and Christ is the perfect man. The stress on the importance of man is the meeting ground of Greek and Christian thought, the main element of Renaissance art, and above all the most important factor of Western civilisation.

The importance of man necessarily implies the importance of reason, of the individual self and of action, in order constantly to improve the human condition and history, as the unfolding of God's design to make of time the midwife of Eternity. Man in Western civilisation is a spiritual being working out the making of his spirituality in time, with a body that is an integral part of him and also part of Nature, informed with energy, whether it is divine or purely material.

Phenomenal reality has substance; it is not illusion; it is either part of God's creation or, as is the case with materialism, it is creation itself. Life is action, not stillness or continuous meditation with a view to the abolition of the self, and art expresses the movement and joy of living, and a constant concern with the self. In Eastern thought, time is illusion, maya, a veil over true life, a stage to prepare for non-life or nirvana. 'Know thyself', said Socrates, whose reflection is basic to Western civilisation. Eastern thought, on the other hand, repudiates the existence of the self, and above all the notion of knowledge through the self; true knowledge thus implies, on the contrary, the abolition of the self, and true life is not action but immobility and continuous meditation to reach perfect stillness, 'the still point of the turning world'.

The nude of Buddhist art is still, if not stiff, and the body does not share the canons of beauty that pertain to Greek or to Renaissance art. The clothes encase the body, which is a fetter or a burden upon spirituality. There is, in this case, none of the grace and flying movement of the Winged Victory of Samothrace which, headless and armless, soars from the earth to which it belongs, to the sky to which it aspires, and which welcomes it as part of an integrated, rational cosmos. The eyes of Buddhist sculptures are not wide open and drinking in the boundless horizon, like those of Greek statues; they are half-closed, eyelids lowered, suggesting continuous meditation, coming sleep, or final disappearance in nirvana. The face is withdrawn, motionless, yet sometimes with a faint smile, even more other-worldly than the Mona Lisa smile, a smile akin to that of the saints or of the stone angels of Gothic cathedrals. It is the smile of perfect spirituality. Yet in spite of these differences, Greek and Eastern art and thought have never been two completely separate worlds, without any inter-changes or deep similarities. India and the Middle East were the melting pots in which Greek thought paid back what it owed to Eastern thought; they became the catalysing elements that enabled Eastern art to express its own spirituality.

There have been continuous interchanges between Hellenic and Eastern thought, and besides that, there were times when these two civilisations were so close to each other in their respective evolutions that both interpenetration and identical

developments were unavoidable. Platonism, the most import-
ant and lasting aspect of Greek thought, bears some remark-
able resemblances to Confucianism, as well as to Buddhism.
Like Confucius, Plato believed that the philosopher-king was
ideally suited to teach society political and social morality,
to say nothing of aesthetics. In both cases, their teaching was
rejected in their lifetime and was revered only after their
death. As with Buddhism, there are aspects of Platonism that
look upon the world as mere appearance or maya, and trans-
cendental truth as the truth of nirvana in which *Karma* has
been abolished and replaced by the perfect union of *Brahman*
with *Atman*. But this, of course, is far from the whole of
Platonism. Side by side with this aspect, which reached its
zenith with neo-Platonism and which continues to underlie
Western philosophic traditions right up to our times, there is
its rationalistic aspect, its love of mathematics, geometry and
music, which have made it possible to look upon the world as
a harmonious and orderly whole, and upon life as being
illumined with glimmers of eternal beauty and truth which
can be reached only beyond death. These notions, com-
pounded with the Judaic sense of history and of the import-
ance of the here and now, together with the awareness of the
immanence of the Divine in all aspects of creation, make
Christianity what it is. At roughly the same time as the birth of
Christianity and probably owing to a similar social evolution,
Buddhism in the form of Mahayana Buddhism began to move
in directions which brought it closer to Christianity. By
admitting the existence of a transcendental spirit and its
incarnation in avatars or Bodhisattvas who, together with
prayers and rituals, can mediate salvation and access to
eternal beatitudes, it rejoins Christianity in offering a growing
urban population a sense of community and shared faith, and
the possibility of facing suffering and injustices with the hope
of a better world to come.

The Greek idea of perfect bodily beauty combined repose
and power with a face reflecting pure being in a state of peace
that nothing of this world could disturb. This idea of beauty of
appearance and perfect harmony of the facial lines is also
part of Buddhist art and thought, which prize above all lack
of movement, and repose, a state of pure being in which all

traces of the agitations of the phenomenal world and of the ego have been shed. The repose of Greek statues is the repose of controlled power pregnant with all the mysterious energies the body contains, but whether they stand still or express movement, Greek statues always convey an impression of peace and harmony which conforms with the relaxed, detached look of the face. Music, the love of geometry and the love of numbers dominate Greek statuary and architecture, and the divine proportions and perfect rationality of the human body, propounded by Pheidias and Praxiteles and end-lessly studied by Raphael, Da Vinci and Michelangelo, have in the end become the fundamental principles of artistic composition and beauty throughout centuries of Western art. The Bible slowly became attuned to Hellas, and Christ and His images and iconography moved from Judea and Byzan-tium to Greece, so as to conform to the Greek idea of beauty, which dominated art until it became academism. Botticelli's Venus, in *The Birth of Venus*, would probably have pleased Praxiteles, and none of his pupils could have done better; it is as good as what he himself could have done, with the differ-ence that Botticelli's Venus is not a goddess but a woman; she is alive, and she is a cross between the Holy Virgin and an ideal of womanhood. She is not quite of the earth, but if the earth could dream, it is surely this Venus it would dream of. Her nudity is purified of all earthly attributes and hallowed by Divinity, therefore she cannot be part of man's life as an individual; she can be part of his thought and imagination only as the embodiment of Spring, true love, art or life.

The perfect equilibrium between spirit and its phenomenal reality, an equilibrium that implies the total incarnation of spirit, was fully achieved during the Middle Ages, that period when Western man equated his awareness of existence with the awareness of the active presence of God or Being in himself, and in all the various aspects of creation. The idea of the world as God's creation, a creation in which God is constantly and actively engaged in transforming time into timelessness, that is to say in separating being from non-being, testifies to the continuous connection of immanence with transcendence, both through natural or habitual bonds between the two and through moments of grace. This idea finds one of its most

accomplished moments of maturation and expression in Dante's *Divine Comedy*, a unique poem in which appearance and content perfectly coincide at the various levels of a structure that images the very structure of creation from its source to its final goal, and back to its source. By then, God had moved away from His aloofness and detachment, and seemed to humanise Himself, becoming more and more present in His creation. Christ became both the sacrificial redeemer and the King, and the Holy Virgin, the *Mater dolorosa*, spread her presence all over Europe, thus underlying the rising importance of woman.

This was the age of Eleanor of Aquitaine, of Petrarch and of the notion of *amour courtois*, as well as the age of Giotto who, carrying forth the work of cathedral sculptors, increased the fluidity of lines and movement that gave an illusion of human reality and drama to his characters. With him, art began to free itself from its basic two dimensions, from stylisation, symbolism, allegory or analogy with the Divine, to become an imaginative representation of essentialised reality or, as Shakespeare put it, to hold the mirror up to Nature. Donatello passed from his early, elegant, Hermes-like David to the realism of his Entombment, his Descent from the Cross and, above all, his Resurrection, which is deeply human and foreshadows Michelangelo's last work. The Resurrection seems to mark the apex of the perfect equilibrium between spirit and phenomenal reality, transcendence and immanence, painting and sculpture. Donatello's stark, elongated figure of St Mary Magdalena, perfectly attuned to Villon's description of La Belle Margot, anticipates modern art and Giacometti.

In both the ancient and Christian worlds, painting and sculpture had developed side by side, with painting seeking its liberation from the influence of sculpture and finally achieving it with Botticelli, Da Vinci, Raphael and Michelangelo. Their work blends Greek perfection of appearance and Christian spirituality and realism, which looks upon Nature as an integral part of creation. From then on, the landscape and figures of a painting belong to the same living world, and the landscape of the *Mona Lisa*, painted between 1503 and 1506, surrounds the human figure with mysterious shadows and connects it with Nature itself. The use of a new type of paint

had reached a stage that was going to make it possible to replace Platonic love of geometry and mathematics, practised by Da Vinci, Michelangelo and their contemporaries, by the direct use of colours. The world was then changing, so was sensibility, and naturally so was art.

What is generally called the Venetian school is no more a school than Impressionism, Cubism and Symbolism are movements. This is academic terminology, which marshals artists into schools and movements as if genius could be transmitted or taught. The fact of the matter is simply that human affinities and similarities of historical background, together with technological developments, necessarily produce similar responses in art. With 'the Venetian school', colour fully won its place in painting by creating shapes, tones, depth and volumes, and relating them one to the other. That is why Cézanne could say that true painting began with the Venetians, who painted directly with colours. Though his statement is arguable, there is no doubt that El Greco, Velasquez, Rembrandt, Rubens, Poussin, Delacroix and the Impressionists could not be fully understood without the Venetian achievement. It is in Venice, a maritime city caught between sky and sea, that colour was born; it is Amsterdam, another maritime city, that gave colour its full range, which Turner and the Impressionists continued to explore on the shores of the North Sea.

In Tintoretto's *Flight into Egypt* of 1583, the landscape is already impressionistic. Veronese's colours anticipate Vermeer's, and Titian's twilights and blends of sea and sky anticipate Rembrandt. His *Pietà* is, like Michelangelo's, his final work, and like the latter he put all his genius into this final challenge to Destiny. The light that hovers around his Christ's head seems to be the same as that which surrounds Rembrandt's Christ in his *Pilgrims of Emmaus*. In Rembrandt's painting this light is reflected on the faces of the three other figures, and also on the hands of Christ, who is neither Piero della Francesca's Pantocrator in *The Resurrection* nor the majestic Christ of El Greco, but a blend of human and divine. With Rembrandt, man, even when incarnated in the perfect man — Christ — never completely loses his humanity. No church, no dogma, no hope of Heaven can fully cleanse him

55

of his human destiny. He may rise with it, like Michelangelo's Christ dragging with Him the redeemed earth, but the sad human face of mankind is never fully merged with the Divine. Man, with Rembrandt, is always on the threshold of night or of death; light is always unreal light spreading its unreal glow on deep red, brown, ochre or black, and on faces imprinted with sadness. Nothing is more moving than the mad laughter of the ochre, brown and black self-portrait called the Cologne self-portrait, painted the year before his death.

Velasquez, Titian and the Venetian School had moved away from the clear-cut line towards colours and volumes, but it was Rembrandt who finally freed painting from the laws of spatial dimensions and asserted the pre-eminence of mental or spiritual states. After him, whether intuitively or consciously, most painters, from Claude Lorrain to Delacroix, Turner, Corot or the Impressionists, responded to the belief that the authentic vision of things consists above all of atomised colours perceived as sensations, free from any *a priori* mental structures. Greek, Byzantine and medieval art up to the thirteenth century were dominated by the straight line, the circle and the sphere, which had been the basic models of man's interpretation of the universe from the Ptolemaic world to that of Dante. By the thirteenth century the circle and the semi-circle were no longer allowed to run their full course; they were made to intersect, so as to produce angles and flying curves. Gothic art was born, and Gothic art is above all movement, fluidity of lines and, in painting as well as in architecture, imitation of the natural world with its spirals, its foliage, its water eddies and its exuberance.

Throughout the Middle Ages, temporal power remained associated with spiritual power, and dependent on it. Charlemagne had to be consecrated by the Pope, and when Henry IV of Germany tried to resist the Papal authority, he was humiliated at Canossa. The Crusades were the means by which the Church kept kings and barons busy, and weakened them. Truth was religious, mediated by God and His Church, unified and not fragmented by reason or by independent rulers. Throughout the eleventh and twelfth centuries kings managed progressively to increase their power, and so did city states with their rising middle classes concerned more and

more with wealth, good living, the realities of this world and the importance of reason. The empiricism and pragmatism of thinkers like Ockham, Roger Bacon and Duns Scotus prepared the way for Francis Bacon, Locke, Descartes and Newton. The enquiring mind of Leonardo, who embodies the spirit of the Renaissance, as much concerned with the realities of this world as with those of the eternal one, produced war machines and flying devices as well as plans to canalise the Arno. Leonardo's love of helicoidal shapes and whirling forms heralds the Baroque, his use of *chiaroscuro* and interplays of light and shade link him with the Venetian School and with Rembrandt, and his fascination with water and its eddies, with whirls of female hair, floating clouds and dancing shapes beckon Botticelli and, beyond him, Rubens. His great contemporary and rival Michelangelo is similarly caught in the conflict between spirituality and appearance, and also moves from classical, Raphaelesque purity of lines to fluidity and curves expressing the tensions and struggles of human figures emerging with difficulty from the material that seems to hold them back as part of the inextricable cosmic unity of organic and inorganic life, and of spirit and matter.

The fifteenth and sixteenth centuries were ages of dazzling genius and profound transformations in the knowledge of the cosmos and in human sensibility. Botticelli, Da Vinci, Raphael, Titian and Michelangelo, to quote only a few, walked side by side in the wake of Dante, Giotto, Piero della Francesca and Donatello, and in the year 1564, when the light flickered out of Michelangelo's tired body, it re-emerged in those of William Shakespeare and Galileo Galilei, thus suggesting that from then on artistic and scientific genius could no longer be incarnated in the same man. This great age has been called, not without reason, the Renaissance, that is to say the rebirth or the re-awakening of man, not in order to take on completely new directions, but to pursue his earthly journey with renewed strength born from the knowledge and the light that was now shining all about him. This knowledge, like all aspects of true knowledge, could not be incarnated without suffering and bloodshed, but, like all true knowledge, it brought about joy and the vision of a new Jerusalem, and

this knowledge was, above all, due to the dialectics of faith and reason, of belief and the certainties of mathematical truth.

From the birth of Greek thought in the sixth century BC, reason and faith, science and belief had developed side by side and most of the time in the same man, whether he was called Anaximander or Pythagoras; they developed not in hostility but in a sustained dialectical relationship that continued throughout the centuries, from Aristotle to Ockham, Duns Scotus and Bacon, until it finally reached the stage when they each had to acknowledge the fact that their respective domains were separate though not opposed and that, though neither truth precluded the other, the truth of the one could not be the truth of the other. The roots of rationalism plunge deep into the history of Western man; they go back to the Greeks, and from Anaximander to Heraclitus, Pythagoras, Democritus, Plato and Aristotle, they exhibit the continuous interplay of the noumenal and the phenomenal, the ideal and the real, the eternal and the appearing. From the thirteenth century onwards, Thomistic Aristotelianism progressively asserted itself against the neo-Platonic Augustinianism that had dominated the Middle Ages, until these two major trends of Western thought ended in forming the substratum of the Renaissance and the Reformation. Rationalism stressed above all the importance of the individual, and of mathematical and empirical truth, without any need of mediation by Platonic Ideas or by an Augustinian God. For Descartes as well as for Voltaire, thought is action; for Hegel and his followers, like Valéry or Mallarmé, thought is all and action is useless. Pascal (Descartes's and Locke's contemporary) remains Augustinian and fully aware of the shortcomings of rationalism and empiricism, and Kant shares his beliefs about reason, without his mystical faith.

The Renaissance and the Reformation exude individualism; Savonarola, Giordano Bruno, Luther, Calvin—all assert the truth of their individual relationship with God, against the orthodoxy of the Church and without any need of its mediation. In the arts Montaigne, Shakespeare, Corneille, Rubens and the Baroque movement assert the self-sufficiency of the individual, and from Descartes's ego to Leibniz's monad,

58

Fichte's ego and Hegel's incarnation of the *Zeitgeist* in the historical individual, the individual is what matters. Descartes and Leibniz still believe in God, Spinoza uses religious terminology and exalts the will, and though he rejects the orthodox God, his idea of the importance of the reality of the whole in order to apprehend and to assess any part of it cannot be confined to rationalism or individualism, for it implies a genuine religious attitude that is not without affinities with Eastern thought. In this thought, ethics must be related either to God or to a Divinity or to the community, otherwise it is uncontrolled individualism in a world in which reason alone decides between good and evil. In the West, whether separated from faith or part of it, reason becomes, from the sixteenth century onwards, the instrument to subjugate Nature and to assert its pre-eminence over men and things. Whether God is pushed aside or, as in the case of the Protestant faith, made to serve the aspirations of rationalism and individualism, He allows human reason to carry out its pursuits of progress and the material betterment of man as part of His final purpose. Rationalism gives pre-eminence to the understanding over imagination and the life of feelings, and this pre-eminence, which became more and more marked from the seventeenth century onwards, could only have a detrimental effect on the arts. Kant reconciled both and retained God as the final recourse of the categorical imperative, and Hegel made of the Absolute the end of the spiritualisation of creation or of the rationalisation of the real.

The Pauline doctrine that only faith and Grace could save man — fallen being — which began to prevail in Catholicism as well as in Protestantism in the sixteenth century, gives life a tragic sense that is deeply felt in the later work of Michelangelo as well as in the work of Shakespeare and Racine. The silence of God in the Pascalian infinite space only accentuates this sense of tragedy. Without His presence, man is doomed to self-destruction, or rather to the destruction of his soul, whatever he does, whether he is successful in life or crushed by it. The glaring light of reason dispels the very existence of God. 'Too much light darkens the mind', said Pascal, who added: 'If He has been once, the Eternal Being is for ever.' God is for ever, but he has ceased to appear to man who, unless he is

59

touched by Grace, will never return to Him, and there lies his tragedy, for he knows that God is, and he knows that he might be separated from Him for ever. Far from assuaging the tragic sense of life, faith sharpens it, for tragedy lies in the fact that God exists but never appears, and man's powers of reasoning are no means to reach Him. Tragic man lives for ever with God's eye upon him, because he can only demand and accept the clear, absolute, unequivocal values that are those of the true life, because for him only acts of Grace and salvation are real, and because, measured by these standards, the world is essentially confused, dark and deprived of reality.

By the end of the sixteenth century, immanence had begun to assume the ascendancy over transcendence, which was either partly pushed aside or seriously questioned by the new rationalism and experimentalism that had begun to emerge in the thirteenth century and was going to reach its full expression with the Reformation and the great discoveries, and with Hobbes, Descartes and Locke. This attitude entails the ascendancy of individual conscience over the conscience of established social and religious institutions, and over the phenomenal world, which more and more lost its subsistent reality and was increasingly looked upon as pure and simple matter. The equilibrium between appearance and spirit was broken, and we had Flemish and German painting in which spiritual suffering and sorrows were represented through expressionistic distortions of the human body, in the art of Hieronymus Bosch, Grünewald, Albrecht Dürer, Baldung Grün and Altdörfer. Even Shakespeare's great spirituality sometimes overflowed its phenomenal appearances and failed to coincide perfectly with them.

The ascendancy of spirit and of individual conscience was far more marked in Germany and, above all, in England, where it culminated in revolution and in the beheading of a king, to be followed in the latter half of the seventeenth century by a diminution of spirituality and by a form of equilibrium in art as well as in politics. In the France of this period, the tendency towards order and control had won the day, and in politics as well as in art a state of overall stability had been reached. It was the state of equilibrium of the French classical age, which was neither that of Greece nor that of the Middle

Ages or the Renaissance. It was an equilibrium based not so much on complete resolutions of conflicts and human and superhuman tensions, as on the acceptance of the principle of moderation in all things, including the demands of spirit. One could, of course, be tempted to conclude that if the demands of spirit were so easily scaled down and controlled to fit a given order or appearance, it was because these demands were in themselves moderate and amenable to established canons of appearance and of beauty. This conclusion seems in the end to be reasonable, for spirit imposes its own appearance or, if not, overflows it, owing to the lack of established structures of social beliefs and conventions, that is to say at times when the spiritual forces at work in society do not quite correspond to the apparently dominant attitudes and beliefs, and therefore find it impossible to achieve equilibrium between spirit and its appearance. This can take place only in moments that mark the point of existential maturation or perfect equilibrium between society and the forces that animate it and their embodiment in adequate phenomenal appearances. After that, these forces break down into their positive and negative aspects, and time has to elapse before new syntheses are formed and before a new moment of maturation can be reached; this cycle will continue until the final exhaustion of spirit or energy in creation.

The French classical age makes it clear that spirituality had reached its apex by the beginning of the seventeenth century, the point at which it had begun to break down into its component elements, and made possible the emergence of the equilibrium between a monarchic and increasingly middle-class society and a more and more subdued spirituality. Subjectivity no longer connected with intersubjectivity or transcendence, therefore it no longer reached the sources of being, and it confined itself to expressing the perfect harmony of well-equilibrated individuate sensibilities operating as monads, in a strictly hierarchical social order. Human passions were no doubt as violent and as unbridled as in the Middle Ages, but man was no longer constantly aware of the presence of spirit and of the need for communion with it. Reason, in this case the understanding, increasingly told men to leave these quests and anxieties to the care of authorities —

whether religious or profane—whose task it was to deal with them. Man's task was to live the life of an *honnête homme*, or to produce well-balanced, harmonious art, in which conceptualism played a more and more important part. Art no longer exhibited the anxiety of struggles with chaotic forces, nor was it the search for truth, but rather the expression of a truth which, if not already fully known from the start, was at least well enough charted to offer few chances of totally unexpected discoveries. 'Ce que l'on conçoit bien s'énonce clairement', said Boileau, anticipating Wittgenstein, and Boileau's dictum was never far away from Racine's mind, since he could say: 'The plan of my tragedy is now made, it only remains for me to write it.' Yet of course, this conceptualism did not fully dominate French, less still European art. In France Claude Lorrain, Tournier, Le Nain and Georges de la Tour continued the great tradition that had stretched from Giotto to Rembrandt—that of art as transmutation of reality, as blend of reality and imagination, as expression through phenomenal reality of the roots of spirituality and the essence of life.

After a great flowering of genius, only barrenness can follow. The human mind and heart must, for a time, lie fallow, so that social growth and change may make it possible for latent ideas to emerge and to find more and more correspondences in society which, through action, ripens them and thus separates the wheat from the chaff, being from non-being. And so it was that rationalism in Western Europe had run its full course through the latter part of the seventeenth century and the greater part of the eighteenth, until it became more and more obvious that it was merely disguising the oppression of spirit which, both in the politico-social field and in human sensibility, was steadily building up the pressures that were going to lead to explosion in all domains. Thus we had the French Revolution, the search for new social and political structures (not found when first sought and not yet found today), and the Romantic movement.

By the eighteenth century, reason had reached its zenith, and as man had been deprived of his ontological finality, he had fallen back on his senses both as the means to give himself the awareness of living and to hide from himself his true finality, which is death and the return to the whole. Senti-

ments separated from thought easily turn to sentimentality, and matter deprived of form or essence turns to lifeless material to be used according to man's will and purpose. In such a world, the only true awareness of life lies in sensation; but as the urge continually to embrace life as sensation cannot be assuaged, it can only end in what it tries to avoid thinking of—death. Don Juan, adorned with Mozart's music and all the periwigs and fineries of eighteenth-century elegance and superficiality, typifies this attitude. He wants to embrace all women, to possess them all, not physically of course (since even he could not find the time to do so), but mentally, affectively, with his inner self, which is a void that nothing can fill. Thus his metaphysical appetite for life is really a call for death, which is ever present and which he seeks in vain to ignore through constant immersion in the life of the senses. Watteau's elegant figures in landscapes or drawing rooms move in a background of Mozartian music and with the constant awareness of death as the ominous presence that stalks all their courtly games and gambols. Eighteenth-century man is, therefore, in spite of his continuous involvement in the life of the senses, essentially tragic, for he knows that the life of the senses cannot last and that unavoidable death for him is not a beginning, but a final, irrevocable closing down of the senses and an end.

Romanticism exhibits a constant coincidence of subjectivity with intersubjectivity, or of individuate immanence with transcendence. One could say that subjectivity, being equated with intersubjectivity and transcendence, is all-powerful and immanent, and therefore it seeks not to use established canons of expression and appearance, but on the contrary to create new moulds to convey its intense spirituality. Blake believed that form creates its own appearance, reducing the many to the one and communicating itself both to the parts and to the whole. This is, of course, more an ideal achieved only by genius than a widely implemented truth, for very often, as was the case with Romanticism, intense spirituality cannot find a mould or appearance to contain it, and therefore it overflows into uncontrolled expressionism, or into creations in which the equilibrium between form and appearance has not been reached.

Minor and decadent Romantic art, by caricaturing and overstressing the basic traits of Romanticism, makes clear what these traits truly are. While the imagination of a Turner or of a Delacroix can control the animal or elemental tensions of their compositions, the weak imagination of minor or decadent Romantic artists is unable to do so, and thus it allows the component elements of their exacerbated individualism and egoism to fall apart. Thence, in their work, the excessive use of the violent contrasts between the grotesque and the pure that had been so dear to Victor Hugo or to Goethe, the love of whatever is singular and mysterious, the flamboyant exoticism and the obsessions with religion, with Gothic cathedrals and their remains, with cemeteries and haunted places; thence also the all-pervading pantheism which leads them to use Nature purely as a means to express or reinforce their own feelings and attitudes. All these various elements which, handled by Coleridge, Wordsworth or the great Romantic painters, were an integral part of the coherence of a work of art, appear in decadent and minor Romantic art as conflicting elements or as standing gratuitously and ostentatiously on their own. Clouds or mists whirling about human figures poised on Promethean rocks; crosses floating on air; moonlit, eerie landscapes, vampires and dark lakes; young maidens, Andromedas in dire danger, waiting for some Perseus to rescue them — each of these elements over-asserts itself in works which, owing to the fact that their authors lacked the genius of their great inspirers and models, merely imitate them, using the materials that genius had previously infused with form as means to suggest a form or essence that is not there and cannot be there, since form must create its own phenomenal appearance.

The lack of coherence between form and appearance simply means that a given artistic sensibility has reached the end of its subterranean social strength, and that a new type of sensibility is about to be born. The haze that floats over some paintings by Constable or Corot, the iridescence of some sea and sky paintings of Turner's, the suggestiveness of Wordsworth and Coleridge, these traits, stressed out of proportion and beyond coherence by lesser talents — such as Poe or Caspar Friedrich — become all too easily incongruous patches of fog

and mist, tinselly shimmerings and wishy-washy vagueness trying in vain to pass for profundity. Géricault's *Raft of the Medusa*, beautiful, moving and well harmonised though it is, nevertheless already announces expressionism through the tensions and tautness of the bodies and the faces, and presents a remarkable contrast with Delacroix's *Massacre of Scio* or *The Death of Sardanapalus*. These two paintings are certainly tense and full of movement, violence, voluptuousness and death, but in both the movement and the colours, meant to suggest blood or fire, are controlled by the overall style which, in varying degrees, characterises all Delacroix's work. However strong the animal and primal violence or the obsession with exotic, clashing colours may be, Delacroix's reason is never unsettled to the point of allowing free rein to individual forces, and the equilibrium of his paintings is never disturbed. His *Pietà* shows a moving blend of realistic suffering and supernal grace, and in his *Lake of Genesareth*, though the boat is as violently tossed by the waves as is Géricault's raft, the Rembrandt-like light that shines upon Christ suggests the power and majesty that can calm and control the seas and lead any boat safely to port. Like most geniuses of his age, like for instance his near-contemporary, Goya, Delacroix was obsessed by violence, blood and death, but though he may have been haunted by monsters, his reason was never asleep; therefore no nightmares or monsters are ever allowed to emerge in his canvases, as they do in those of Goya, as they did in those of Hieronymus Bosch or of the medieval expressionists such as Baldung Grün, Altdörfer or Urs Graf, with whom Goya's tormented genius seems to have so much in common.

In France, Cartesianism, the heir of Greek rationalism, dies hard, and conceptualism has always played an important part in French art, in which expressionism finds no place and surrealism is more like an alien verruca than part of the texture of the face. Rousseau, the archetypal hero of Romanticism, has greater affinities with Goethe, Schiller, Kant, German idealism and English Romanticism than with the *Encyclopédistes* who rejected him, or with French Romanticism which, with Musset, Lamartine, Vigny, the early Hugo and Ingres, carries a good deal of rhetoric and conceptualism. It is only with the later Hugo, whom Baudelaire hailed as a

voyant, with Symbolism, and with Delacroix and Berlioz that the French imagination becomes attuned with German and English imagination which, from Blake to Coleridge, Shelley, Turner, Goethe and Schiller, had continued the great Platonic tradition of idealism and the Schopenhauerian notion of art as revelatory creativeness and music.

The insistence upon the direct, materialistic expression of feelings and things necessarily leads to expressionism as it flourished at the beginning of the twentieth century, or to the mimetic fallacy—the attempt to express tears with tears, cries with cries, and suffering with writhings and contortions of the body or the face. Both expressionism and the mimetic fallacy, if not controlled by style, can only bring forth, not true aesthetic responses, but purely emotional and sometimes kinetic responses that involve neither aesthetic judgment nor imagination. Art is transmutation and harmonisation of conflicting or contrasting elements, therefore tensions and suffering must not be expressed by contorted bodies or faces, or cries, which are merely photographic reproductions or imitations of Nature, but by purely artistic means, that is to say colours, volumes, harmonious relationships and coherence, and, as far as poetry is concerned, perfect orchestration of words. The grief of a face is more movingly expressed by the eyes and their relationship with the face, than by distortions that run the risk of provoking laughter rather than sympathy and sorrow. The use of purely naturalistic means to convey spirituality reveals the domination of artistic structure and purpose by a conceptual finality which, instead of reaching its true fulfilment through the free interplay and coherence of its parts, is imposed by the artist, who shapes his material in order to achieve the aims he has in mind.

By the second half of the nineteenth century, the sensuousness and plasticity of Keats had become the frozen image of Parnassian and Pre-Raphaelite art, while the musicality, indirectness and suggestiveness of Shelley had become the life force of Symbolism, which follows Pater's dictum that 'all art aspires to the condition of music' and Verlaine's injunction: 'De la musique avant toute chose.' Mallarmé shared these beliefs, and as for Rimbaud, true life was not in this world, but elsewhere, in the Hegelian, transcendental act of creation.

_____ 66

Naturalism and materialism, which are practically synonymous, could be said to be one of the tail ends of Romanticism, the others being Symbolism and transcendentalism, which have extremely close affinities, Parnassian and Pre-Raphaelite art having been too short-lived to produce any worthwhile impact. With Naturalism, subjectivity lost the transcendental aspirations it had exhibited during Romanticism. It was purely confined to itself, without any relationship with intersubjectivity, and it was confined to itself not as a basis of truth, as it was with Romanticism, but as a basis of observation, with a view to discovering the truth outside itself, in a so-called perfectly objective, materialistic reality. Truth, in this case, was scientific and nothing else, and it implied no finality or order, except the determinism of matter of which man is a part. As for matter, since it no longer possessed any entelechy that man could respect or feel connected with, it was purely what man made it and made of it.

Conceptualism was therefore unavoidable, and conceptualism has not produced any great art, even although it has, in some cases, contributed to art. Naturalism, that of Zola or Courbet, that is to say the attempt to imitate or exactly reproduce Nature, could only see Nature not as a living whole, but as dead, fragmented matter; it was, in this respect, the very opposite of realism, which looks upon life, history and Nature as a whole and as endowed with a spirituality or essence that precludes fragmentation or the reduction of truth to imitations or reproductions of disconnected sections of reality. Truth is essence, extracted from the whole and made into a coherence or image of the whole by the imagination. Naturalism necessarily implies a materialistic conception of life and reality, and as far as art is concerned, it can lead only to automatism and mechanicalness, admirably fulfilled by photography. That is why Impressionism's dream of camera-like objectivity and scientifically observed and reproduced reality led it right out of reality. Its attempts to grasp the elusive, the continuously changing colours of appearances and the fleetingness of things finally dissolved concrete shapes and volumes and resulted in Turnerian, misty blends of sea and sky and shimmering dances of light, colours and shade, as mysterious and as evanescent as a Symbolist poem. The

principles involved in Impressionism and Symbolism were certainly different, but the final results were very much alike.

Symbolism was a total denial of the reality of matter, the only reality being, in this case, that of the creative subjectivity fused with intersubjectivity in the act of artistic creation. It was no doubt an exacerbation of subjectivity due to the artist's total alienation from a society that professed values and pursued ends whose materialism, superficiality and lack of concern with real truth were a complete denial of the reality and value of art, except as entertainment or decoration. The artist therefore sought truth in himself, in the flight of his imagination towards it, and in the apprehension of the graph of this flight, which was nothing less than his self-conscious subjectivity apprehended as creativity. The result was something essentially fluid, imprecise, evanescent, musical, both all-embracing in its intersubjectivity and deeply singular in its essentialised subjectivity. The truth of this art was, in spite of its profane climate and repudiation of religion, a deeply religious truth, the kind of truth that the saint or the mystic discovers and that, in both cases, commits the whole man to an experience that takes him out of the world and connects him with Being.

In painting, Cézanne's presence and influence, much ignored in his lifetime, soon asserted themselves and went on to dominate twentieth-century art. Whether the starting point of his painting was Nature or a human being, Cézanne sought to extract from it the structural essence that gave it life. The appearance he constructed was not a copy of the model, but an appearing of its essence as the painter's subjectivity apprehended it and linked it with intersubjectivity or with the subsistent, perennial essence. Nature, with him, was again treated, not as a means to an end, as was the case with Romanticism, but as a living reality, the essence of which man apprehends through his own subjectivity. Though they used different means and lacked either the patience or the mental power of Cézanne's search for the perennial structures of life, Gauguin and Van Gogh set about asking the same questions and like him apprehending the true reality that lies beyond appearances.

Braque and Picasso developed Cubism which, with them,

became more intellectual, less concerned with the perennial essences of things and more concerned with their phenomenality or appearance. This led to an extraordinary explosion and exploration of appearances, in which Picasso's genius found its full scope in painting as well as in sculpture. The final phase of Cubism coincided with Surrealism, which marked a total rejection of the rational and of any kind of representation in art. Society being irrational, torn by violence and wars and longing for nihilism and nothingness, Surrealistic art endeavoured to mirror or to reflect these attitudes; the result was that the artist could only retreat, not into his subjectivity, but into his own private world, which is without contact with other subjectivities. Madness, dreams, nightmares and delirium formed the background from which art was supposed to emerge. Needless to say, the results of such strictly surrealistic approaches to art are, on the whole, fairly negligible, with the exception of some works by Max Ernst and Tanguy. Surrealism has no doubt had a liberating, therapeutic influence on certain aspects of conceptualism, but its foremost, or at least its most notorious representative, Salvador Dali, is above all an entertainer, a kind of circus performer constantly intent upon surprising his ever-present imaginary audience with all kinds of exhibitionistic devices.

This, of course, is anything but the whole story of twentieth-century art. Rodin, the greatest sculptor since the end of the Renaissance, gave his *Balzac* some of the strength and depth of reality only elsewhere to be found in Michelangelo's work. The created and the uncreated are inextricably intermingled in aspects that suggest God's creation out of chaos. After him Giacometti, Henry Moore, Barbara Hepworth continued, each in his or her own way, to explore the reality of man and Nature as part of a unified creation. So did painters such as Rouault, Renoir, Matisse, Léger, Braque and Picasso, and writers such as Thomas Mann, Yeats, Valéry, Claudel, Eliot, Faulkner, Mauriac, Malraux, Pasternak, and a few others whose mention would show clearly that, in spite of a great deal of superficiality which tries to pass as art, the spirit of man has not, by any means, said its last word.

The lights that illumine man's journey through time belong as much, if not more, to the world of art and philosophy as to

the world of science and religion, for art expresses, from its inception, the first glimmers of man's consciousness, his relationship with the universe and the transfigurations that enable him to assess its mystery, as well as the mystery of his soul. In the beginning, on the shores of Hellas, science and religion were at one with art and philosophy; the wisdom of Oedipus echoed that of Athena, and the love of Antigone that of Amphitrite born from the waves of the Heraclitean sea, the source of life and continuous change. Then the world was new, the world was one; now it is like a demented sea strewn with the flotsam of religion and the jetsam of science, and it is from these fragments that man, waiting on the shore, must find guidance and salvation. Art is now made up of the débris of both, and man plays with it to while away time or to disguise, in one way or another, the bareness of the surroundings in which he lives.

4

Art and Subjectivity

There remains the genius of the poet himself. The greatest
thing about this genius is the power of losing itself in its object,
its impersonality. We seem to be reading, not the poetry of a
poet about things, but the poetry of things themselves. That
things have their poetry not because of what we make them
symbols of, but because of their own movement and life, is
what Lucretius proves once and for all to mankind.

G. SANTAYANA, *Three Philosophical Poets*[1]

The artist necessarily possesses a Keatsian negative capability
of being all things. He is impersonal in the sense that his
persona, his character, his beliefs, his concepts are completely
in abeyance during the course of the creative act. This does
not mean that the creative subject has ceased to exist or has
simply become a *tabula rasa* upon which things and experi-
ences mechanically inscribe their imprint. There is no *tabula
rasa* in the mind. As an activity, the mind is bound to have
some kind of orientation that is determined by its essential
structure. This activity is the inner self or subjectivity of the
individuate being, part of Being, and therefore endowed, by
its essence, with the possibility of apprehending aspects of it,
in rare moments of union with it.

Subjectivity is the individuate mind, intuition or uncon-
taminated spirituality knowing itself as objective truth, part of
the totality of Being. Knowledge is always a fusion of subject-
ivity and objectivity, and the subjective is its very basis in the
sense that it is the activity through which the fusion takes
place. Whatever reality we grant to the phenomenal world, it
cannot be reduced to pure phenomenalism, sense-experience

71

and empiricism, without falling into materialism, and finally into irrationality. Beyond the phenomenality of things, there is a reality that is only apprehensible to the mind as intuition. and to the mind as understanding — the one apprehending the object as a whole, the other cognising the object through mind-made attributes and concepts.

The notion that poetry and art are mere subjectivity and that science alone is objective is without foundation. The scientist is subjective in the construction of his hypotheses and their verification or rejection, and in the apprehension of the inner reality of things, which is not accessible to sense-experience. The mathematical symbols that he uses, and the laws of matter that he discovers, are verifiable, refutable and teachable, and constitute therefore objective knowledge, handled by the understanding. The knowledge that art supplies is also objective, but in a different way from that supplied by science. Though some aspects of art are, if one accepts certain principles, partly verifiable and refutable by reason, the experience of art is not teachable; it is apprehensible only as an organic whole that modifies the experience of the apprehending subject. The creative mind produces an organic entity that embodies objective knowledge; it can do so either individually or apparently collectively, as in Homeric times, in the Middle Ages and in the ages of the ballads and the cathedrals, as the expression of a closely-knit, religion-bound, community life. I say 'apparently', for however heteroclite the various elements of *The Iliad* and *The Odyssey* may be, it was Homer who shaped them and fused them into the coherences that the world knows and admires. In a similar way, the cathedrals were built under the inspiration of architects, and the ballads were composed by individuals making use of popular lore and wisdom. Van Gogh gives us Van Gogh's truth, which in its most accomplished aspects is universal; the builders of cathedrals give us the truth of their historical time, a truth that united individuals in shared beliefs, dreams, longings and fears, and that is the projection of their inner selves into one single, shared archetype — the cathedral — the link between Heaven and earth. These two types of truth are, each in its respective way, objective, and apprehensible by other men, whoever they may be.

The essential *I* or self is by definition an activity continuously changing and modifying itself through knowledge of itself, through the creative act. The creative self projects its essence into an object or image of a theme or experience with which it has strong affinities and possibilities of achieving oneness. The object by itself is, but does not exist as a mental entity; it is what it is; it has its own purpose, which is to be what it is, but no purpose or qualities for man, except those that come to it through the mind of man making itself through its projections into the objects around it, and through its continuously developing self-knowledge. The object, pervaded by the self-consciousness of the knowing subject, ceases being an object in itself, to become an object for a subjectivity, part of this subjectivity which, through the apprehension and knowledge of this object, passes from a pure self-contemplating, non-knowing subjectivity to a subjectivity knowing itself in the act of knowing an object. The result of this act is, in the case of art, the creation of an objective entity, a source of knowledge for other subjectivities. The important point is that the self can know itself only through the mediation of something which is not itself; it cannot know itself as pure consciousness of self, for self-consciousness by itself is merely a transparent ideality, a shaft of light, the existence of which is revealed only if some grain of dust or object breaks its transparency. Even God can only know Himself, not as pure ideation, but through the reality of time and creation. Man can truly know himself only through the merging of his own subjectivity as self-knowing subjectivity objectifying itself, with intersubjectivity or transcendence, and thus connecting with it. Intersubjectivity, transcendence or absolute reason can be temporarily reached only through the perfect identification of the subject with the object, once they have both been shorn of all their contingent attributes and reduced to their respective essences.

The identification of subject with object, the apprehension of the reality or essence of an object can take place only through intuition, which makes it possible to grasp the wholeness of the object apprehended without cognising it or abstracting its component elements. The creative act, which could be equated with the activity of the creative imagination,

is a disinterested activity or a pure and simple orientation towards the total apprehension of the object so as to constitute with the subject a synthesis in which the particular and the universal, form and appearance are one, for the form is the subject knowing itself as objective truth. The creative act is the expression of a subjectivity tending towards objectivity, in the sense that the inner *I* or subjectivity has shed all mental and affective contingencies in order to reach the essential truth, which coincides with the truth of Being, and which is thus absolute freedom. In order to be able to do this, individuate subjectivity has to negate itself as finitude and to apprehend itself through mind as infinite; it has to reach the stage at which it has ceased to be aware of itself as subjectivity and has, for a brief moment that is timeless, become aware of itself as intersubjectivity. This negating process is the way of the artist and also that of the saint and the mystic. It is necessarily painful, for it implies a rejection of the instinct of immediate self-satisfaction, of materiality and of life as something to be prized purely for its own sake. This rejection is not a question of will, for the will is not an abstraction operating on thought in order to impose upon it a given direction, but thought knowing itself and therefore willing itself to be what it is, that is to say freedom.

The artist reaches freedom through art, as communion with Being. The saint and the mystic reach it through communion with God. The process is the same for all; the thought or light that guides them and motivates their actions must be an activity or a projection towards the universal and the objective, and not towards the gratification of contingent self-interests or desires. This projection towards the universal does not imply a negation or a rejection of life, but it does imply the awareness that life and time are not ends in themselves, but finite apprehensions of infinity. As such they must be made use of according to the strength of the individuate vision or intuition, in order to mediate and actualise the positive aspects of essence that are destined for Eternity. Man's essence impels him towards Being, from which it has issued and which can be reached only through the total abolition of the subjective at the material level, and through its partial abolition at the spiritual level. What is abolished at the

spiritual level is what is negated by being and turned into non-being, so that being alone rejoins Being, which is not a perfect, closed entity, but the activity that unites all subjectivities or essences as part of itself, knowing themselves through it and in it, while it knows them all and itself through them.

Death in all its forms is, most of the time, painful; the creative act is both a death and a birth, and as such both painful and joyous in its outcome. The groping through a tunnel towards light — the light of truth — is painful and trying; the final emergence into light and truth is an ineffable joy. Though art is not an inherent part of Christianity, it has been profoundly marked by it. The awareness of transcendence or of the Absolute gives to art and to the notion of death a range of meaning unthinkable in a world that does not relate immanence to transcendence or does not posit transcendence. If subjectivity is only an emanation of matter or a shadow deprived of reality, its destruction is nothing more than a stage in the unfolding of the process of natural growth and death. But if subjectivity is part of Being, then its destruction, or its alienation from Being for which it longs, is something awesome and tragic, without any hope of consolation. The agony of Faust's death is inconceivable in a world in which the fall of Icarus into the sea is an event not different in kind from the act of ploughing or harvesting. Death, in this case, is a pure and simple closing down of the senses, something incommensurable with the possible loss of Eternity. From the moment God revealed Himself to man through the Incarnation, spirituality became the source of truth and the highest form of life, since it alone makes possible the achievement of true life in time and, consequently, out of time. The search for the Absolute, once the Absolute is posited, is man's main search, as well as that of the artist who, far from incarnating the Absolute or the Divine in human appearance, as is the case with Greek art, projects the human towards the Absolute, which pervades the human appearance with spirit, and moulds it as part of integrated orchestrations intent upon spirit.

The history of the life of art is the history of its oscillations between these two most important aspects of life — the spiritual and its phenomenal appearance, the thing-in-itself or

essence, and the phenomenon. In primitive, animistic art, the phenomenon is informed with spirit, and to control the phenomenon is to control its spirit. So art is a form of ritual, a magic act through which man endeavours to control Nature and its forces. In Greek art, the ideal — the world of Ideas — and the phenomenal world apprehended in its plenitude by the senses, are completely separated, and life finds its fulfilment in well-equilibrated phenomenality. Beauty is the perfect equilibrium between the ideal and its appearance; this equilibrium is consistent with the laws of numbers, and is both true and good. Aesthetics and morality coincide and obey the same laws of moderation and balance between extremes; *in medio stat virtus*. The great Greek tragedies illustrate above all attempts at disturbing the immutable order of divine or natural laws, and this is something that man, a finite being, must pay for with his suffering and his life. Death restores the broken equilibrium and is the sacrifice that becomes a source of joy.

Christianity, carrying with it the ascendancy of spirit over matter, necessarily brings about a progressive diminution of the importance of the phenomenon, whose only value is that it is more or less informed with spirit. When there is harmony between the two, as was the case during the full blossoming of religious art, the artistic representation of the phenomenal world and of the world of man himself is imprinted with beauty and with spiritual elevation. The human figure and face, suffused with spirituality, are beautiful, and remain so until the stage is reached when beauty no longer implies beauty of appearance, but rests above all on the appearing of a profound and all-pervading spirituality, which more and more assumes the ascendancy and thus results in concentration on the inner spirituality of things and not on their appearance. When this stage is finally reached, as was the case with Romanticism, whether appearances are ugly or beautiful does not matter; what matters is their spirituality, their subjectivity or essence seeking to express itself until it becomes at last transcendental subjectivity or intersubjectivity. Then the Hunchback of Notre Dame is as beautiful as Praxiteles' Hermes or Michelangelo's David, prostitutes are as pure as saints and as beautiful as Venus, and the beggar's rags and the

76

body itself become transparent, letting through the trans-forming spiritual light.

Subjectivity truly emerges with Christianity, that is to say with the Incarnation and with the awareness of the importance of the creature as part of God's creation. The Greeks too believed in the soul, but their souls, whether on the Acropolis, on the banks of the Acheron or in the Empyrean, were most of the time the plaything of warring gods and goddesses; that is why their art is not turned towards impassive divinities, but towards mind-created ideals that confer upon phenomenality the imprint of divine beauty. This beauty conforms in some ways with Plato's words: 'I mean by beauty of form something made of lines and circles and with surfaces and solid shapes composed of straight and circular lines, drawn with the compass, the tracing-line and the square. For these forms are not, like others, only beautiful in certain conditions; they are beautiful in themselves.' (*Philebus*) To this Platonic notion of lines and circles must be added the Pythagorean faith in numbers and mathematics as providing ideal correspondences with reality. The Greek phenomenal world corresponds to mathematical laws composing a celestial music that only the pure intellect can apprehend. The Greeks aimed at ideal perfection, and the line and shape of the body in their sculpture is ideally, mathematically and musically perfect; the eyes are blank, staring at far-away eternity; no tremor of life shatters their serenity, which is the serenity of the void. The mask of the face is set in its immutable beauty, expressing one single abstraction which, whether it is grace, strength or power, is completely unruffled and undistorted by feelings or emotions. At most a vague, quaint smile may sometimes float on a feminine face. Apollo, Venus or the Winged Victory of Samothrace are all they appear to be—perfect signs of concepts, fixed upon eternity. None of them carries the slightest trace of subjectivity. They all embody the total objectivity of a subjectivity that equates itself with the phenomenal embodiment of mind. Given the necessary inspiration or genius, all these marvellous sculptures, and also samples of architecture, could very well have been produced by the same mind and the same hand—an ideal mind guiding an ideal hand, a hand that never trembles or falters, because

77

the heart that feeds it always beats with the same regular, un-disturbed rhythm. The Greeks reserved their passions and their violence for life, and for their tragedies; they kept them carefully away from their statuary. They did not sculpt mothers, fathers, daughters or lovers; they sculpted gods and goddesses, or heroes embodying an ideal or a concept, but not human feelings of motherhood, fatherhood, or man-woman love. It took Christianity to bring these aspects of life into art.

A mother's breast rises and falls with the ups and downs of maternal love, and this love permeates her face, whether it has been painted by Raphael, Da Vinci or Rembrandt. The very face of Christ changes according to the hand that painted it or sculpted it, and it bears the mark of the subjectivity that guided the hand. Not so in Greek art, even though it was, like any other art, the product of individual subjectivities. The Greeks did not believe that transcendence, or for them the ideal, was the subsistent essence of man and creation, and, this being so, that it could be apprehended or glimpsed by man merging his own subjectivity with transcendence, which for them was completely separated from the finite world. The Greeks looked upon the ideal as a purely intelligible concept, and not as something real and suffusing the phe-nomenal world. Therefore they apprehended the ideal only through mind, which universalises and abolishes individua-tions and replaces them by ideations. Thence the similarity of their artistic productions, the excellence of which varies according to the talent or genius that created them. The Greek ideal, whether it embodied movement or stillness, was an image of overwhelming serenity, undisturbed by any internal agitation. Whether such agitation had never existed, or had been conquered, there is no means of knowing. Happi-ness in this case is not a resolution of conflicts and a shedding of the impediments that prevent the self from reaching the state of non-self as part of intersubjectivity, but a state of relaxation and strength under perfect control, and the equilibrium of the satisfied senses.

What the Greeks prized most was the body, the fount of all sensations; Achilles in the underworld made this point clear when he said that he would rather be a living swineherd than a dead king. Herakles conscientiously carries out his twelve

imposed labours, which have nothing in common with Christ's fourteen stations of the Cross. His dream on earth, if he ever had one, is not to redeem men, so as to enable them to live eternally in the presence of their Maker, but for himself to return to the Empyrean to live peacefully among gods and demi-gods with whom he will enjoy hunting, fishing and perhaps a few amorous games such as gods and goddesses were wont to indulge in. Meanwhile, he is hoping to enjoy this kind of sport as long as possible on earth, but alas for him, it is not to be so. Caught in the trammels of his wife's pettiness and jealousy (she herself is a pawn of feuding gods and goddesses), he is made to die by fire, but certainly not for the redemption of mankind. His sculptural representations are a perfect embodiment of power and strength, carrying no suggestion of agitation under his breast, or possible torment under his brow. The Apollo of the Temple of Olympia or Praxiteles' Apollo or Hermes all show the same marvellous equilibrium between strength and grace.

The Greeks could stand pain; so could the stoic Romans; their souls were not involved with the body, as is the case with Christianity; they were in another world. Thus the body did not express suffering. The Laocoön, caught and half-stifled in the coils of a sea-snake, though he shows great physical tension, does not display any sign of spiritual suffering; he displays, above all, muscular exertions, physical pain, and acceptance of a merciless fate which, as he was well aware, did not spare the gods themselves. Greek heroes die or deal death without a tremor or a thought of the inhumanity of their actions. Achilles kills Hector in single combat, and calmly drags his dead body around the walls of Troy before handing it back to his old father Priam for burial. Niobe dared to offend Latona, who was Apollo's mother; as a result, Latona had all children put to death, while she became a heart-broken mother finally turned to stone. Yet, whatever suffering the Greeks may have had to endure, they never allowed any signs of sorrow or pain to disturb the serenity of the faces of their statues. The statues of Niobe, in spite of her sorrows, have the plasticity and stiffness of stone. What Rimbaud called *vraie vie* is elsewhere, in the Elysian fields, beyond the shadows of Plato's cave, in the world of ideas intuited by mind as pure

imagination. Life is flux, flowing water, fleeting shadows, a world of pure phenomenalism in which the appearing is all. With Christianity, the appearing is the appearing of essence, of the thing-in-itself, and the individuate subjectivity, aware of its source, is intent upon projecting itself out of itself into the other, or into others. What matters is the other, other beings, other subjectivities, and intersubjectivity, in which lie true knowledge and the perfect fulfilment of the human dream, once man is liberated from all the impediments that pertain to the finite world. In the Greek world, the gods themselves are not free, and the greatest and noblest virtue in their world is not the absolute, pure love of the Christian world, but resignation and acceptance of a fully comprehended tragic destiny.

The Greeks did not have the Christian sense of evil, but they had the awareness that man's tragic plight could be only temporarily assuaged through a catharsis, achieved by reliving their great myths, embodied in the tragedies of Aeschylus and Sophocles. Man found his unity by projecting himself through the images of the archetypal figures that symbolise and epitomise his fate on earth. The Greeks were fully aware that man can be one only through uniting phenomenal reality with its shadow, and existential man with the great shadow that hovers over the millennia of his past and future and will, in the end, enfold the whole of life. They were aware of the vital need for myth, an awareness that Christianity maintained and provided for, through its own legends and through the life of Christ and the saints, but which, alas, faded away during the last century and has practically disappeared in ours. In the Greek world, any attempt made by man to forget his station and to raise himself to the level of the gods was ruthlessly crushed through awe-inspiring examples that the human mind has not yet forgotten. The pride of Oedipus and that of Agamemnon or Niobe were levelled down to such suffering and tears that no mortal could ever again dream of emulating their ambition or hubris. Suffering had no redemptory virtue whatsoever; it was purely retributory and elevating, but neither hope nor compassion tempered its poignancy. All men lived and died as creatures on their own, and not as part of a God-informed creation. The bright Attic light shone with

equal indifference on men and gods, all ruled by the inflexible Parcae.

This world of pure appearances and sensuousness was bound to come to an end. Socrates' 'know thyself', Plato's notion of time as the becoming of eternity, herald this end, and not long after them the overcrowded Olympus was swept clean and replaced by the omnipresence of one single, indescribable, unrepresentable Divinity — God, a God whose looming presence Socrates and Plato had caught glimpses of and announced to their fellow-beings. Spirit, which until then had been apprehensible only by mind or *nous* as a purely mental ideation, progressively becomes part of the consciousness of man, as subjectivity aware of its own essence, and therefore of spirit or of transcendence which informs it. A new era begins; man becomes steadily more aware of spirit as inherent in his own nature, and therefore he feels himself part of the structural forms that underlie the life of Nature as well as that of society and history. These structural forms can be apprehended only when they crystallise in, or are objectified by, singular individuals who represent them and who, by making of their strength and importance an integral part of human consciousness, make a vital contribution to the continuous movement of history. In moments of crisis, a people that becomes aware of the dangers threatening its existence, and that still has enough spirit or aspiration towards transcendence left in itself, always manages to throw up the genius who can translate the needs of his fellow-beings into words and actions that contribute to the making of history and finally to the spiritualisation of creation. A most telling example is Napoleon, who represents the spirit of his age at one of the greatest watersheds of mankind. If there is no spirituality left, as was the case with the Roman Empire in the fourth century AD, then the time has come to die and to return to the loam from which new births will rise — in this case Christianity. Spiritual revolutions always erupt practically unheralded by any premonitory signs, which are generally the discoveries of hindsight. There are perhaps some vapours floating over an apparently extinct volcano that suddenly erupts and fills the world around it with light and transforming fire, but nothing more. One may be aware of the deca-

dence, the loss of direction, the lack of will to live, as were the Romans living their last days in the grey twilight of their dying gods, but one is not aware of what is coming or what ought to be done to transform an agony into a new life.

There is no hazard or chance in history, there is only the progressive knowledge of its unfolding through the actualisation of its spiritual forms and the winnowing of the essential from the non-essential, of the true from the false, of what has perenniality from what has none. This takes place through man, and through the beliefs and thoughts that determine his attitude to art, philosophy and history. Christianity marks the emergence of the subjective and of the interiorisation of the spiritual that is no longer out there with Plato's inaccessible Idea, but in man aware of his reliance on his Creator, Who is the very cause of his existence. 'Love', as Eliot said, 'is the prime mover', and Being is love, self-creating love that informs being. The individuate being's awareness of Being, through the self as subjectivity, carries with it the awareness that love is the essence of life and the true ontological reality of man. So it is easy to understand why the main theme of Christian painting has been the Mother and Child in all its aspects, from Christ's childhood to His death. Nothing can express pure love better than the relationship of mother to child, and child to mother. The pagan world had no idea of this kind of relationship. Zeus was no loving creator, he himself having begun by murdering his father; as for his legitimate wife, Hera, she was famed only for her waywardness and jealousy. For the Greeks, love was embodied in Aphrodite, that is to say in eroticism, and in the Platonic notion of *agape*. The individual having been deprived of spirituality, these two aspects of love were not connected, and they therefore existed apart as pure sexuality on the one hand and perfect friendship or mysticism on the other. This lack of spirituality meant that human suffering had no place or importance in Greek art.

The Incarnation changed this, and Christ became with the Holy Virgin the true symbol of love, and in painting, sculpture and to a lesser extent poetry, these two occupied a dominant place in Western art right up to the end of the nineteenth century. Most paintings of the Holy Virgin's face as *Mater*

82

dolorosa exhibit in varying ways the great sadness that pierces her heart and the awareness of her noble suffering for the sake of creation. Her face makes it clear that she is love itself united with the Divine. This awareness transfigures every one of her attitudes, whether she is the happy mother with her child or the mother who holds his dead body in her lap. With Christianity, creation is God's word, uttered in time, therefore all things that take place in it are interrelated, and can only be understood as part of the wholeness to which they belong. Art, like religion, aims at connecting the individuate and the particular with the whole, at creating timelessness, and thus fulfilling St Augustine's belief that 'God made man that man might become God'. These words have now come to pass, yet certainly not as St Augustine intended them. For him, man could truly be himself only in union with God. In fact, he was in this respect faithful to the neo-Platonism of Plotinus upon which he had fed; for him, as for Plato, truth and true knowledge can be found only in the contemplation of God, or in the intelligible apprehension of the Idea. 'The intellective soul is impassible, all but utterly untouched by matter, for it is in the nature of things separated from the body; its act is the act of Intellection or Intuition or True Knowing of real existences; it has its being in eternal contemplation of the Divine.' (Plotinus)[2]

Making the invisible visible, translating the forms of spirituality into apprehensible appearance is the perennial problem of art. Homer, the fount from which Western civilisation has drunk since its inception, depicted gods, demi-gods and men involved in fabulous actions and legends that have become part of the ethos of the Western world. His heroes, the archetypes of beliefs and attitudes that are perennial to man, move about in a world given above all to action, to a clear-cut vision of human realities and to the acceptance of the rules of the game, laid down by the Parcae. The world of Aeschylus and Sophocles is not very different; their heroes and heroines do their duty dry-eyed, stiff in their pride, neither asking for, nor offering, pity. Antigone, leading her blind father, is the most moving creation to be found in a harsh, very unsentimental world, in which man's noblest task is to endure whatever comes to him. Nothing in her suggests either hope or the vague

awareness of the greatness of a task which will have numinous results. The world is a bull-ring, in which the toreador and the bull, face to face in the implacable justice of the noonday sun, understand their tragic destiny and fulfil it with an impassible dignity and an elevation that leave the watching gods breathless at the extraordinary lesson that the finite world, whether on four or two legs, can give the Immortals.

Greek statuary, the product of one of the great moments of man's imagination, has endowed the human body with canons of beauty and harmony that have haunted man's imagination ever since. The notion of beauty, ideal beauty, is Greek, and no other people has contributed more to the revelation of its appearance. After such a dazzling dream, the world seemed to sink back into rest for fifteen centuries, before it could again muster the imagination required to give spirit a new impulse and another chance of manifesting itself to man. Dante and Giotto, immortal contemporaries, heralded the rebirth of art, which, after a brief lull in the fourteenth century, burst forth into the greatest flowering of artistic genius the world had ever known. It marks the perfect marriage of realism with imagination, the natural with the supernatural, immanence with transcendence, and time with Eternity. With Giotto Greek beauty becomes suffused with spiritual naturalness and true humanity, while Fra Angelico, Piero della Francesca, Botticelli, Raphael, Da Vinci and Michelangelo render the Divine and the spiritual apprehensible to the senses, through shapes that retain the ideal of Greek beauty but carry with them something that Greek art did not possess, namely the underlying tremor of a deeply felt and an ever-present spiritual life. In their art, form and content, appearance and reality are one, in a perfect equilibrium born of the illuminations of the creative subjectivity in moments of awareness of its connection with intersubjectivity or transcendence.

It would, of course, be a mistake to believe that the art of this period conforms perfectly and *in toto* with the dominant artistic canons of the age. Far from it. The blend between Greek ideal beauty and Christian realism, and between idealised architectural shapes and the chromatic variations of phenomenal reality, only takes place progressively. *The Martyrdom of St Sebastian* by Pollaiuolo illustrates this point.

The background is a well-delineated Tuscan landscape; the martyrdom is enacted in the foreground with St Sebastian tied up on a high stake and surrounded by a group of soldiers, the whole forming a perfect pyramidal symmetry, customary in the art of the age. The saint exhibits a body of perfect Greek beauty, and a completely serene face which makes it obvious that the arrows shot at him have no more effect upon him than they have on the soldiers who shoot them; the soldiers, in turn, shoot with a detachment and zest that suggest they would not care at all if the saint were replaced by an archer's target.

In spite of the changes initiated by Da Vinci, Bellini and Giorgione, the transition between Florentine love of stone and Venetian chromatism was anything but complete. On the whole, landscape was still painted as landscape, and its figures were fixed in practically architectural stillness, without being integrated in it. Basaiti's *St Jerome* shows clearly that the saint has nothing to do with the landscape that surrounds him. Titian's *St Jerome* shows, on the contrary, that the figure and the landscape — compounded of rocks and trees — form an organic whole, involved in the same movement. On the other hand, Giorgione, whose nude, Venus-like figures of the *Fête Champêtre* were to reappear in Titian as well as in Manet's *Déjeuner sur l'Herbe*, exhibits in some of his works the still persisting chasm between the Florentine stress upon mass, lines and geometrical structures, and the Venetian stress upon colours, fluidity and lyricism. His painting *The Tempest* was described by his contemporaries as 'a landscape on canvas, with a thunderstorm and a soldier'. The description is perfectly adequate; the three items mentioned are indeed all there, neatly placed side by side, yet completely unrelated one to the other. The practically naked feminine figure in the foreground seems to have strayed straight from the ancient world into the Venetian landscape. She is poised in the most uncomfortable of positions, suckling a child and staring ahead of her, totally unaware of the presence of the young soldier, himself gazing past her, on the other side of the stream. Beyond this Arcadian foreground, the sky is torn by lightning illuminating the buildings in the middle ground, itself surrounded by trees which, in spite of this threatening storm, stand as still as lines in geometrical constructions. The tension

of the sky is thus negated by the landscape and by the complete detachment of the human figures. Each of them neither disturbs nor absorbs the other; all is what it is, in a world of pure phenomenalism which pertains to Greek art. The landscape, on the other hand, is a Venetian landscape, pervaded with the sense of spirituality that, later, enabled Giorgione to turn the carefree young woman of *The Tempest* into the grey-haired, sad-eyed, furrowed face of the old woman of the painting called *Col Tempo.*

Dutch and German painting of that period show that man, instead of gazing towards Heaven and ideal beauty, turns his gaze on himself and on the world immediately around him, which he depicts with the accuracy and the respect he habitually has for things fully informed with spirituality. This trend reaches its zenith with the great Dutch and Flemish masters who, starting from Nature and natural objects, extract from them their basic truth and embody it in artistic creations containing the essence of life transmuted by imagination. Their mastery and the power of their imagination are such that they confer upon actions or humble scenes of everyday life the halo of perenniality. Whether the scene painted is the carcass of an ox, a surgical operation, a night watch or a self-portrait, Rembrandt extracts the essence of the action or situation portrayed, and connects it with intersubjectivity or transcendence.

In a world of sky and sea and without any strong geographical landmarks, light, with its changing transformations through clouds and water, is the most important protagonist of the imagination, and no one has equalled Dutch painters in their descriptions or suggestions of the fleetingness of light, its interplay with darkness and its complex reflections on the human face. Dutch painters, starting from transient aspects of Nature or everyday aspects of life, and relating their organic essence to their own subjectivity, produced aspects of truth, seen *sub specie aeternitatis.* Each object, each fragment of reality is transmuted from the phenomenal world into the transcendence of art, in which the glittering reflections of a copper pan are as full of mysteries as those that hallow the holy host. Instead of bringing the divine to earth, the Dutch painters confer sacredness upon Nature which, in its humble

manifestations, is as imprinted with religious feelings as the great religious paintings of the *quattrocento*. The Divine and the spiritual move from the face of Christ, the Holy Virgin or the saints to the faces of ordinary people who, as good Protestants, humanise religion and make of it an active part of everyday life.

No category of painting expresses better than Dutch the history and the psyche of a nation. The self-portraits of Rembrandt could appropriately be described as the growth of a soul on earth. The progressive unfolding of the mystery of life through the changing shades of light, the wrinkles, the furrows, the texture of the skin, is a moving religious experience expressed by the subjectivity of outstanding genius. Dutch painters were fully aware of the transience of all aspects of life. They were truly realistic in the sense that their art was an exact correspondence of the thoughts, sensibility, social and religious conscience of their time. Their deeply religious, God-fearing society respected God's presence in all aspects of creation, and saw in Nature a manifestation of His will. Therefore Nature was treated with reverence and allowed to express its essence, which the artist sought to apprehend through its phenomenal appearance. Dutch art is pervaded with the philosophical realism that dominated the Middle Ages and the Renaissance, the main tenets of which are that Nature is informed with God's subsistent essence, and that truth is above all analogical, part of a vast system of integrated correspondences centred upon God, and therefore finally resting upon certainty of belief rather than on mathematical or scientific verification. The earth reflects the Heavens, the microcosm the macrocosm; all things are interrelated, without being mediated by any other golden means to which they can be referred, except God. The rationalism of the great schoolmen, from Aquinas to Grosseteste, Roger Bacon, William of Ockham and others, had not seen any fundamental opposition between reason and faith, and though the mystery of God's existence could be neither explained nor verified, reason did not find any grounds to doubt His existence. The rising experimentalism and scientific attitude of some of them towards natural phenomena never dreamt of doing away with the Augustinian notion that God is the ulti-

mate criterion and mediator of truth. In that world, all things were part of creation informed with essence, and truth could reside only in the Being that was the ground of the individuate essences of creation.

These beliefs retained their ascendancy in the Western world until the beginning of the seventeenth century. By then the scientific attitude ceased referring truth to analogies and resemblances or to a still centre, and equated it with mathematical reasoning and verifiable evidence. From then on, the Creator became separated from His creation, transcendence from immanence, imagination from intellect, and emotions from thought. Imagination, described by Pascal as 'la folle du logis', needed to be controlled by the intellect, and emotion and passions must be subdued by reason, otherwise they reduced man to a life of instincts. Descartes, with his search for and reliance upon mathematical truth, and his advocacy of the control of passions, sums up this attitude. Language both embodies and mirrors this profound alteration in the structure of man's sensibility; it no longer directly expresses reality, but the mind's reflection of reality; it therefore becomes rhetorical, indirect, abstract, euphuistic, periphrastic and precious, in France as well as in England. As for painting, it oscillates between the realism of Claude Lorrain, De la Tour, Le Nain or Rembrandt and conceptual orchestrations already evident in the work of Poussin or Rubens, who marks the culminating point of the unsteady equilibrium between form and appearance before it topples into baroque.

By the eighteenth century the break had taken place; transcendence had disappeared and art concentrated on the fleeting aspects of human emotions reduced to sensations. The reverence for Nature, deprived of reality and of any connection with the Divine, had disappeared. Nature was purely and simply matter, to be used by man as he pleased; it was looked at through carriage windows, and, on the whole, confined to beautiful parks strewn with Greek statuary, or with the elegant, effete figures of Watteau, Fragonard or Gainsborough. All this composed a world of perfect gracefulness and control, with passions and spirituality dominated by reason, and religion by quietism. Having lost the faith of his forebears in the living, purposive wholeness of the universe,

eighteenth-century man was desperately aware that time was fleeting past him, and that the only thing that mattered was to live through sensations. Death was constantly lurking in the wings of this gay world overshadowed by the forebodings of coming apocalypse. 'I feel, therefore I am', could be its battle cry, and such is the plangency of this deeply felt human cry that nearly a century later Keats echoed it with the words: 'O for a life of sensations rather than of thoughts!' Spirituality being a mere emanation of immanence disconnected from transcendence, art was more concerned with the beauty of appearance than with its substance. Man was convinced that rationality had mastered the brute forces of Nature, and the numerous man-and-horse statues of the period testify to the widespread strength of this belief. It was no longer an age of faith, but of surfeit of power, of wealth, gracious living and frolicking, to the sound of Mozartian music. It was the age of the minuet, of baroque and rococo architecture; it was an age of fantasy, but not of imagination which, having been turned away from the true reality of things, was soon going to explode in all directions, under the pent-up rage of the exploited classes and the vision of a new era for man. Blake, Rousseau and Napoleon were looming on the horizon.

The classical equilibrium between appearance and spirit was for Romanticism not only impossible but also unacceptable, for anthropomorphous spirit had become conscious of itself to the point that it could accept only the fulfilment of its own self as its proper finality. Matter was treated more and more with Shelleyan impatience, and the world, its conventions and its social ties as mere impediments to spirit intent upon knowing itself as spirit alone. The earth and its phenomenal manifestations participated in this exaltation, and rose towards heights whence spirit could contemplate itself reflected in all things, connecting everything to itself. How exciting it must have been to live in days when spirit, free from the earth, free from God or gods, was entranced with its own essence and was concerned only with its Promethean self-discovery and the propagation of its own truth! 'Talk to us about ourselves', said the crowd to the poet, and the poet, in this case Victor Hugo, replied: 'Hélas, quand je vous parle de moi, je vous parle de vous. Comment ne le sentez-vous pas?

Ah insensé, qui crois que je ne suis pas toi!'[3] 'When I speak about myself, I speak about you; I am you!'—this is the very crux of Romantic art. The poet or the painter, in being truly himself, is also the other, and is therefore all men; he is so, not when he talks to others about themselves—an impossible task, since he can know the others only as objects—but when he talks about himself, whom he knows through the only knowledge that is possible, the knowledge of a subjectivity connecting with intersubjectivity. Subjectivity can be a source of true knowledge only if it transcends the personal and the ego, which are isolating and limiting, and connects with inter-subjectivity or the absolute. It can only do so, not as an abstraction but as an incarnation through which it knows itself in the act of knowing, and through such an act it is aware of its connections and interrelationships with everything that surrounds it and with the time to which it belongs, which has been transcended through absorption into the self trans-formed into absolute subjectivity.

Twenty-five centuries ago, Heraclitus, the source of so many truths, had already said: 'It is my own true self that I have sought, and that I have tried to interpret', thus echoing the Delphic oracle: 'Know thyself', that is to say: interpret the oracle yourself, do not ask others to do it for you, for you would only get an interpretation of their own selves. Truth is necessarily subjective, but the subjective is not the ego, which is merely a constricting lid, reflecting the appearances, conventions and expectations of society. 'Le moi', said Pascal, 'est haïssable'. 'Le moi' is the ego, but not subjectivity. It is, in fact, what truly hides and disguises; it is the social mask or persona, which social life progressively fashions and fixes upon every individual who, on the whole, knows himself and is known only as this persona, character or mask that is his appearance. This is so even for creative minds, who often allow their persona to take over and go on producing what Hopkins called Parnassian poetry, which is merely a repeti-tion of empty appearances without substance or truly imagin-ative content, or paintings repeating well-worn themes and compositions, that is to say pure and simple academism. Flaubert's or Eliot's search for impersonality was really an eschewing of persona or impersonation, in order to reach the

true self or essence of man. Yeats began by wearing the persona of the Romantic poet obsessed by dream-laden lakes and Celtic legends; but his true genius soon led him to realise that the truth lay not in the props of a romantic and poetical stage, but in the 'foul rag-and-bone shop of the heart'. The heart is concrete and real, and it belongs not to the world of ideas or the absolute, but to the individuate being, living in time and aware of time, that is to say aware of its finitude, its possibilities of infinity, and its being a meeting point of spirit and materiality.

Late Romanticism transformed reverence for Nature into the subjection of Nature to the individual's changing moods and self-interests. The object is no longer allowed to exhibit its own essence; it is swamped and overwhelmed by the subjectivity of the apprehending subject, who believes not in philosophical realism but in pantheism dominated by immanent subjectivity. The specific character of an individual or a thing is stressed, sometimes to the point of caricature, so as to meet the mental and affective leanings of the creative subjectivity, which, in conformity with the aspirations of the age, is more and more intent upon pure immanentism. This tendency increases to the point where, in the end, it causes Romanticism to move completely away from Wordsworth's 'sense sublime Of something far more deeply interfused' of *Tintern Abbey*, or from Coleridge's

> O dread and silent mount! I gazed upon thee,
> Till thou still present to the bodily sense
> Didst vanish from my thoughts; entranced in prayer
> I worshipped the invisible alone.
> (*Hymn before Sunrise*)

Therefore one passes from immanent, spirit-pervaded Nature, to Nature as matter to be moulded by the creative subject, and from the grandiose image of the world of Constable, Turner or Delacroix to the mind-controlled world of Courbet, Millais and Naturalism.

By the end of the nineteenth century, spirit was at a low ebb, and the immanentist subjectivity, which throughout the century had incarnated spirit and mediated it into self-

knowledge, tended to turn in more and more upon itself, to be a subjectivity on its own without any aspiration towards, or connection with, any form of transcendence. It was therefore a subjectivity that had lost the awareness of its essential finality and operated at a level where the concern for the truth of being and connection with intersubjectivity was no longer the primary aim of the creative mind. It sought knowledge either through itself as pure creativity, without any essential ground or finality, or in the contemplation of the world as an object only to be cognised through scientific methods. Kant's lesson, expounded in the Second Preface of the *Critique of Pure Reason*, had been completely forgotten: 'I have been compelled to abolish knowledge in order to make room for belief. Metaphysical dogmatism, that is to say the erroneous notion that it is possible to progress in metaphysics without carrying out a critique of pure reason, is the true basis of all revolts against morality and of every aspect of incredulity, an incredulity which is at all times extremely dogmatic.'

Faith in scientific knowledge, which means above all faith in technology and in the practice of scientific methods disconnected from mathematical science, has led to a new type of dogmatism, the dogmatism of scientism in philosophy, in art as well as in everyday life. Kant was aware of the danger incurred by a civilisation dominated and led by the worship of knowledge, one which excludes the world of belief and thus excludes the most vital aspects of human life—religion, art and morality. Democritus's dream of reducing morality to knowledge, the dream of a materialistic, science-dominated world, is not tenable. Morality belongs to the domain of spirit, i.e. religion and aesthetics, implying, as previously mentioned, an aspiration towards transcendence. A perfectly equilibrated philosophical system, like that of Plato, Spinoza, Kant or Hegel, possesses an aesthetic beauty that can outlive its epistemological value, a beauty of perfect mathematical proportions, and it is as much part of art as of pure rationality and logic. The task for man now is to restore the balance between knowledge and belief, and to give its due place to spirit.

5

Art and Knowledge

Philosophy is akin to poetry, and both of them seek to express that ultimate good sense which we term civilisation. In each case there is reference to forms beyond the direct meaning of words. Poetry allies itself to metre, philosophy to mathematic patterns.

<div align="right">A. N. WHITEHEAD, Modes of Thought[1]</div>

Art is a fruit that grows in man, like a fruit on a plant, or a child in its mother's womb. But whereas the fruit of the plant, the fruit of the animal, the fruit in the mother's womb, assume autonomous and natural forms, art, the spiritual fruit of man, usually shows an absurd resemblance to the aspect of something else. Only in our own epoch have painting and sculpture been liberated from the aspect of a mandolin, a president in a Prince Albert, a battle, a landscape. I love nature, but not its substitutes. Naturalist illusionist art is a substitute for nature. I remember a discussion with Mondrian in which he distinguished between art and nature, saying that art is artificial and nature natural. I do not share his opinion. I believe that nature is not in opposition to art. Art is of natural origin and is sublimated and spiritualized through the sublimation of man.

<div align="right">HANS ARP[2]</div>

For Whitehead as well as for all true practitioners of art, art is knowledge, different from, yet as valid as, philosophic knowledge. For Arp, art is an organic and natural manifestation and expression of the human psyche, in the same way as a fruit is the final expression of the tree. The fruit makes possible the perpetuation of the tree and is therefore an inherent component of its finality. Man could possibly live

without art, which, though not part of his biological development, is undeniably part of his spiritual growth, and therefore part of the making of himself as man. Whether one can or cannot conclude that art is absolutely necessary to man's life, history and pre-history tell us that from the moment man became man and passed from the solitary, predatory, hunting state to tribal and social life with nomadic settlements and cultivation, he has constantly practised some form of art, such as painting or ritualistic dances or music.

Although art and magic, and art and knowledge, are not one and the same concept, both imply a mastery of the form and appearance of the thing observed, which is an aspect of knowledge. The masters of Lascaux knew exactly what a buffalo was like, how it behaved, and what its life meant to them. There existed between animal and man an intimate relationship, which the mind of the painter sought to convey by expressing knowledge and mastery of the animal, through the representation of its image. Civilised man, whether he used the idealised naturalism of the Greeks, the spiritualised appearances of the Renaissance, the realistic explorations of Dutch and Flemish art, the Romantic apprehension of Nature in all its manifestations, or its transformation into imaginative representations or abstractions in the twentieth century, always expresses and reveals through art profound and more or less harmonised tensions between man and the cosmos, and man and man, which constitute the most important aspect of human knowledge. The art of the East, a world in which man is only an unwilling, passing pilgrim, is an art of noble and refined detachment from the cosmos, an art of meditation, elevation and aspiration towards non-being, and it therefore confers upon the various appearances of being a growing evanescence that conveys to the mind the suggestion that the most important thing is not to know, but to cease being part of the quest for knowledge and to be re-absorbed into not-knowing and non-being. Western art, on the other hand, is profoundly anthropomorphic; its basic concern is man — man in relation to the cosmos, the gods, God, Nature and society, and whatever the relationship may be, it rests upon the human self in tension, seeking to grasp and to know the truth and to render the invisible visible.

94

The Greeks brought their gods to earth and saw them as men and women of eternal beauty and equilibrium. Michelangelo's *Pietà*, the image of mankind clutching its tragic destiny, redeeming itself through its sorrows and sufferings hallowed by transcendental joy, bears at the same time the imprint of the tensions and suffering of the genius who created it and sought to know himself through it. Rembrandt's anguished face caught between flashes of light and falling night, Van Gogh's knarled olive trees and violent expressionism, all bear the imprint of Western man's desire to uncover, whatever the cost, the mystery of his own nature and destiny. Eastern man too is concerned with knowledge, but not so much with the knowledge of man, transient pilgrim on the way towards non-being, but with Nature, with things and with life itself, which is something greater than man and expresses the essence of Being better than he can do through his fleetingness. The basic difference between these two points of view is summed up in their respective attitudes to time. Whether in the case of the Incarnation for the Christians, or in that of Allah's revelation of His truth to Mahomet, time, for both the Christian and the Islamic world, is made to be the mediator of Eternity. In the East, time — maya — is illusion, metaphysical evil, to be lived through in order to shed impurities and reach nirvana, and the individual never counts for much in relation to the whole, whether religious, political or cosmic.

A work of art is always an objective entity embodying a truth or a type of knowledge that can be apprehended only subjectively. It comes to life through a subjectivity intent upon knowing the true nature of human and cosmic reality through its apprehension by the essence or transcendental *I* of a subject that merges with the transcendental essence of the reality he is seeking to know, and forms an organic, coherent whole called the work of art. This organic whole is like a diamond that has been quarried from the deep mine where lies the truth of man and of the cosmos. Once it has been quarried, any man can pick it up and descry through it aspects of the world that combine the truth of the one who originally quarried and shaped it, with that of the one who views it at any given moment. The work of art is a fragment of truth — of transcendental origin or otherwise — to which all who have the

necessary imagination to encompass some of its aspects, and the humility to approach it in a mood of will-less receptivity, can have access. But the knowledge that it embodies, and that it can therefore impart to those who come to it, is not of the kind that can be quantified, verified or refuted through logical arguments or mathematical proofs. Its only grounds of verification are the human heart and the human imagination, which do not apply scientific criteria and measurements, but which certainly do apply the principles of coherence, organic wholeness and conformity with the verisimilitude of human experience. This latter principle ties imagination to reality, and implies a clear distinction between imagination, always starting from or connecting with the real, and fantasy, which is pure mental speculation completely disconnected from practical or even theoretical reality. 'Imagination', said Wordsworth, 'is reason in its most exalted mood'; and reason, even when exalted, remains reason. Art necessarily implies a discipline as rigorous and as exacting as that of science, and the kind of knowledge that it pursues and that it yields is, again, as rigorous and as valid as that of science, although it is pursued and assessed by different methods. The fact is that there are various kinds of knowledge. Basically, there is religious knowledge, philosophic knowledge, artistic knowledge and scientific knowledge.

Religious knowledge is not knowledge about something that can be imparted to others; it is subjective knowledge, and although reason plays an important part in it, its ultimate truth is a matter of belief and certainty, and not a matter of demonstration and verification or refutation, as is the case with scientific knowledge. Philosophic knowledge rests above all on logical arguments, backed when required by mathematics, yet its pursuit of the ultimate truths leads it into intellectual speculations that necessarily involve subjectivity and, at the highest level, imagination used in a manner akin to that displayed by any practitioner of the arts. Plato is the most telling example of the use of imagination and consequently of poetic language in philosophy. Bergson and Heidegger certainly emulate him in that. Artistic knowledge participates in both religious and scientific knowledge, provided the latter is not reduced to technology and observation

entirely separated from the mathematical sciences. The work of art is an objective entity, which, though not subject to scientific laws, has its own laws which, if not satisfied, leave upon it weaknesses and flaws. Although the work of art is always apprehended subjectively, the subjectivity involved in artistic apprehension and appreciation is not the subjectivity of religious experience. The most important difference between the two lies in the fact that the former lacks the ontological dimension of the latter. Besides, one must add that although there is in every work of art a certain residuum of mystery, as there is in religion, art is a human creation finally commensurate with the human mind and the human imagination, parts of finite life, while God or transcendence, which are the grounds of the religious experience, are incommensurate with human reality.

The words that the poet uses are the words used by everybody else; each is laden with its own individual accretions, which are brought into play in the reading or hearing of any poem. Similarly, the shapes, volumes and colours used by painters and sculptors are also part of everyday life, and as every individual has his own special receptivity towards them, this attitude necessarily comes into play whenever he is confronted with them. Words are signs and images of reality or experience apprehended by the mind, and colours are attributes of reality also apprehended by the mind. The mind thus corresponds to the way things are, and expresses or images universal Nature; therefore words and colours have, besides their individual connotations, a universal meaning accepted by the whole ethnic and cultural group that uses them or understands them. So the interpretation and appreciation of art, however individual a matter each may be, take place within certain boundaries that have universal validity; thus though there may naturally be variation from one individual's interpretation and appreciation of a given work of art to another's, there will also be many points in common, though not a fixed magnetic pole or common denominator as is the case with religion. That is why, all in all, the apprehension of the work of art and artistic knowledge cannot be equated with religious experience and religious knowledge.

Like religion and philosophy, in the West as well as in the

97

East, art is both an agent and an expression of the harmonious order of the universe; it is a translucence of being, made visible and apprehensible to the senses and the mind of individuate being; it is perennial truth ever shining out of the chaotic, uncharted darkness of the cosmos and of human life. In the East as well as in the West, before Christ and after Christ, art is above all a kind of logos, an incarnation of spirit or of the inner reality of life, caught between the tensions of being and not-being. Valéry said: 'I call great art an art which commits the whole man and which calls forth all the faculties of another to interest themselves in it and to understand it.'[3] 'There exists a pictorial truth of things', said Cézanne. Tche-Tao said: 'The brush is used to bring things out of chaos.' The conscious and subconscious purpose of art is to bring order and harmony out of chaos, light and truth out of darkness, and the artist and the philosopher join the scientist in trying to reveal to men the truth of the universe, whether it is the truth of the laws of Nature or the truth of the laws of human life and human experience. Art is a symbolic language with its essential laws of association and coherence, based on the structural correspondences between the perennial laws or truths of creation and man's mind, which intuits and reveals them.

The importance of art in the life of mankind has become part of man's consciousness only in modern times. Battles, violent changes of political régimes, the vagaries and deaths of kings, formed, for a long time, the landmarks and substance of the history of man, always written with hindsight. Greek statuary, Plato, the cathedrals, *The Divine Comedy*, Da Vinci, Michelangelo, Shakespeare, Rembrandt were until recently only footnotes to history, and in their lifetimes these great geniuses were mere pawns or instruments in the hands of their rulers. Whether he liked it or not, Michelangelo had to give up sculpture to paint the ceiling of the Sistine Chapel, and Da Vinci had to do the biddings of Ludovic Sforza. Yet, as Yeats put it in his poem *The Statues*:

> . . . the men
> That with a mallet or a chisel modelled these
> Calculations that look but casual flesh, put down

All Asiatic vague immensities,
And not the banks of oars that swam upon
The many-headed foam at Salamis.
Europe put off that foam when Phidias
Gave women dreams and dreams their looking-glass.

The Greek mastery of forms, which expresses the divine, their gift of archetypal beauty to men, their rationality and love of numbers certainly did more to impose order upon chaos and anarchy and to make possible the growth of civilisation than their military victories over Asiatic invaders. Indeed, when the Greeks were in their turn defeated by the Romans, their spirituality, their art and civilisation triumphed over their victors, in the same way as powerless Christianity was more effective than the Roman legions. The spirit will always have its say, and Shakespeare plays a greater part in the shaping of the English mind and sensibility than all the kings of his history plays, whose lives are above all what he made them. The creative artist is a maker, not a dreamer; he sees far away, ahead of his fellow men, and deep down to the very dawn of their past, into the ground that feeds their beings and is the meeting point of where they came from and where they are going to. The poet dreams no more than Plato, Newton, Kant or Einstein. His dreams are not — as is often thought by those who equate poetry with phantasms — other-worldliness and vain pursuits of will o' the wisps. Blake, Wordsworth, Coleridge, Yeats sought to map out or evoke their visions of New Jerusalems, of new patterns of life, of an Edenic past now lost, with the same precision that Rembrandt applied to painting the texture of the meaning-laden wrinkles of his face, or Einstein to the verification of his hypothesis that Newton's laws of gravitation could not fully account for the order and life of the cosmos. As Blake said: 'A Spirit and a Vision are not, as the modern philosophy supposes, a cloudy vapour or a nothing: they are organized and minutely articulated beyond all that the mortal and perishing nature can produce. He who does not imagine in stronger and better lineaments, and in stronger and better light than his perishing mortal eye can see, does not imagine at all.'[4]

The goal of art is truth, not beauty. 'Beauty', said St

99

Augustine, 'is the praise which Nature offers to God.' No doubt all great artists of the past, from Michelangelo to Rembrandt, subscribed to this view, and if one replaced the word 'God' by the word 'transcendence', the consensus would be wider and would embrace most of nineteenth- and twentieth-century art. Is beauty Wordsworth's memory of the 'immortal sea Which brought us hither', bringing the moment in which the poet can 'see the Children sport upon the shore'? Is it Baudelaire's or Poe's Platonic reflections of the supernal world? Or is it the dream or vision of perfect lines and harmony that the human soul strives to achieve through centuries of purgatories and beatitudes and of deaths and rebirths through the bitter sea of life?

> How many centuries spent
> The sedentary soul
> In toils of measurement
> Beyond eagle or mole,
> Beyond hearing or seeing
> Or Archimedes' guess,
> To raise into being
> That loveliness

So Yeats mused whether beauty was not a fragrant plant that the soul progressively and slowly brings out of *anima mundi*. Whatever beauty is, it is always something transphenomenal and unreal; it is an imaginative representation of what is not, and, like happiness, a by-product but not an object of wilful pursuit. Keats's 'Beauty is truth, truth beauty' is not far wrong. Beauty and truth are in a certain sense identical, and in another different. What lacks truth, truth to its form, truth to its inner laws of coherence and organicity, cannot be beautiful. An idea—the idea of love, for instance, is true if it coincides perfectly with its form or essence, which is both individual and universal. When this idea is given existence, that is to say objective appearance, and thus made apprehensible to the senses and to consciousness, then the object or objective entity that embodies it and reflects it is beautiful. Therefore beauty can be a reflection of truth, but this reflection is not apprehensible through the understand-

100

ing, which, confining itself to perceptions and concepts apprehended separately as attributes of reality but not as reality itself, cannot apprehend the work of art as a whole. It is apprehensible only through intuition or imagination, which transcend divisions and reach the world of beauty and truth, which is infinite, continuously open, creative and changing according to time and individual sensibility.

Beauty is not conformity with an imaginary ideal or form, or with some object or concept. There is no particular form of beauty, for beauty is not an ideal archetype from which all beauty derives. There is no ideal beauty, there is only the fact of being, or not being, beautiful. Helen was beautiful, but she was not beauty itself, for not only are there aspects of her which are not beautiful, but she is not beautiful for all men at all times. The canons of beauty vary with time and place. Beauty is therefore an apprehension of the mind, and whether, as Plato suggests, it stirs in the mind a 'memory' of something that belongs to the mind by reason of its 'kinship with universal nature', that is to say offers us glimmers of the nature of beauty, or whether it is something that answers our own inherent longings and inclinations, beauty is not a particular entity but a universal notion applied to something that the individual mind describes as beautiful. The single ideally, perfectly beautiful, true or good particular could only be God, and God, as the embodiment of all particularised perfections, becomes thus the universal source and centre of all perfections. This is an intelligible notion that naturally tends to equate the criteria of goodness, truth or beauty with a transparency of being, apprehended by mind. It is therefore the universal mind of forms, apprehended by a subjectivity — a marriage of the subjective with the intersubjective, from which results an object or symbolic entity which is beautiful.

Beauty is not a quality that is perceived by the senses, like *tall, yellow* or *bright*, but a mental apprehension of the form of an object or an experience. The work of art is a mental construct, or a symbolic entity, embodying a truth conveyed through aesthetic pleasure, born from the subjective recreation of the harmony and coherence of the contemplated object. If there is a lack of harmony or coherence, this flaw breaks the unfolding of the aesthetic impulse, and one is left

101

with the dissatisfaction and the frustration of not having reached fulfilment. One therefore looks rationally for the cause of the dissatisfaction — or conversely, for the cause of satisfaction, if satisfaction there has been. But if there has been no satisfaction, there is no knowledge, or very little knowledge, for knowledge is what satisfies the mind objectively. There is knowledge in knowing why one is not satisfied, but this kind of knowledge is not the knowledge of aesthetic experience; it is only the knowledge of knowing why an aesthetic experience has not truly taken place, and therefore, if it has not taken place, the truth that this experience ought to have contained, and ought to have revealed, has not been revealed, because in the end it has not been created. In scientific knowledge, on the other hand, the mind leaves itself out of the object it cognises; it cognises it not by becoming it, but by knowing it purely as an object, through its qualities and component elements.

Knowledge is always relative to man's mind and to the range of his experience. What is true at one time as establishing a coherence between ideas and facts, is true only for the experience prevailing at that given time, and it is replaced later by new truths in conformity with the world of things and of mind to which these truths belong. Certain aspects of Dante's *Divine Comedy*, for example, were true at the time of its composition but are no longer so now. Truth being reality apprehended by mind, true knowledge enfolds both the negative and the positive aspects of this reality — truth and error — as part of being. Truth is truth whether its subject matter is great or small; yet of course, the subject matter determines the scope and potential greatness of a work of art. A Descent from the Cross, whether in paint or in marble, offers more scope for greatness than a game of bowls or a fishing party. A work of art is more or less beautiful according to the coherence and harmony of its parts, and the ugly itself can be made part of the aesthetically beautiful, if it is made to be a coherent and harmonious part of the whole.

The appreciation of art is vitiated by the fact that aesthetic judgments are declared to be essentially subjective, and as such very often reduced to a matter of personal appreciation and taste, therefore beyond the pale of any serious discussion.

The upholders of objectivity seem to claim that things, which of course exist in themselves, can be cognised only through concepts, or apprehended objectively through linguistic analyses of percepts grasped by a kind of perfectly mechanical or abstract understanding absolutely free from any subjective interference. This is an illusion, for even machines have their results read and interpreted by men; as for the mind, it is not a recording machine, but an active and orientated entity, to say nothing of the fact that it is always one given mind, and not an abstraction called mind. The subjective or indefinable inner *I* of the creator, which unifies the imaginative apprehensions and perceptions of reality into the organic whole that is the work of art, is not a manifestation of the will or of the understanding. It is the true essence of the subject acting as a pure, uncontaminated, catalysing receptivity which fuses the inner reality of the object or experience it contemplates into a concrete entity suffused with the self-knowledge of its creator, and is a source of knowledge for anyone who approaches it in the spirit of receptivity and disinterestedness in which it was created.

The inner reality of man, a reality that can be glimpsed only by saints and geniuses, is both an awareness of, and a longing to recapture, the oneness of Being. Art is above all this attempt, which requires an annihilation of the personality, so as to allow the emergence of the not-self, the essence, or openness towards a possible union with Being. That is why art is always both a birth and a death, a birth to a new life, and a return to the great memory of Plato, what Goethe called the mothers, the world-ocean of Celtic mythology, the *anima mundi*, or the womb of being and non-being. The subjectivity of artistic creation is that of individuate essence or form which connects with, or remembers and reveals, the universal and the timeless. It has nothing to do with the ego, that is with the conscious, wilful self, which can be neither creative nor capable of true artistic interpretation. Artistic interpretation, if it is authentic, is a kind of creativity, seeking to rediscover the creative process and the true component elements of the work of art, and to pass an aesthetic judgment on it. Though there are no scientific criteria by which one could ascertain the excellence of a work of art, and though, strictly speaking,

there are no laws which, if mastered and applied, could unfailingly produce good results, there are recognisable principles that pertain to all art throughout the ages and that, when applied, indicate the basis of the artistic beauty and excellence of a work of art.

There are, it seems to me, at least three such principles: the principle of coherence of the whole, the principle of organicism of the component parts, and the principle of relevance to reality and to the reality of the age in which the work of art was composed. The principle of coherence has been examined in the previous chapter. Sufficient to stress here the fact that the work of art must form an imaginative whole that holds in tension or in perfectly harmonised relationships its various component elements which, while retaining their essential individuality, cohere into oneness. This is the image of the perfect society in which the individual retains his own individuality and integrity, and yet is only valuable and only functions well as part of an integrated and homogeneous whole. This is a notion that excludes both the Marxist absorption of the individual into the greater, immanent whole of society, and the free-for-all individualism and anarchy of so-called liberal societies. A living reality, whether artistic or political, implies both a coherence of the parts to the whole, and a living and organic reality of the parts that compose this whole. Yet this necessary coherence must be neither willed nor imposed from the outside; it must emerge as part and parcel of the form and finality of the component parts, which must, as if of their own free will, adhere to the whole. One has, therefore, a kind of necessity that flows from the essence of the whole apprehended as an idea or as a vision of this whole, and from the essence of the parts apprehended as its necessary component elements by the creative imagination that fuses them into the symbolic entity that is the work of art. The principle of necessary coherence and organicism precludes wilful distortions and enforcement of concepts that would fragment the work of art, or tie it to the understanding of the subject who created it and consequently prevent it from reaching the transcendental level of imagination as revelatory of truth and universal values.

The principle of relevance to the time in which a work is

104

produced does not mean that the work of art must be confined to that time, or could only be fully apprehended from within it. That would be the very opposite of art which, by nature, transcends time. A twentieth-century work of art can carry any amount of re-interpretation of the past, since the past is what has been lived, brought to life again through the inner *I* of the creative mind; but it could not bear fantasy's flights into the twenty-first century, for such flights could not be integrated in a work that sets about to blend realism and imagination. The art of any given period always expresses aspects of the consciousness that this period has of itself, sums up all previous aspects of art, and prolongs them towards the future. While one can no longer paint as was customary during the Renaissance, or write Ronsardian sonnets, one cannot, either, project oneself into the twenty-first or twenty-second century without leaving the domain of art and true knowledge to pass into that of fantasy, flight from reality and science fiction — which could, of course, become the reality of tomorrow. The knowledge of the art of any given epoch is the knowledge of aspects of the true spirit of that epoch, other aspects of which are revealed by philosophy and by political and social life.

True knowledge is always a form of self-knowledge, that is to say knowledge of oneself through an object, an experience, an emotion or a thought, whatever it may be. The self knows itself only as *at-tention* to, or towards, something; by itself, unfocussed or non-mediated, it is a mere virtuality, an abeyance of activity, though certainly not a nothingness, for nothingness is non-being, and the self has being, is part of being, is informed with Being and is the means by which Being makes itself through time. It makes itself through moments of intense consciousness, during which the self as essence or pure subjectivity connects and blends with the essence of things or that of human experiences, and brings to light their truth or inner reality and, by so doing, separates being from nonbeing, that is to say extracts from being what belongs to the Eternal and gives it the phenomenal, apprehensible appearance that makes knowledge possible.

Art is the appearing of essence, an incarnation of substance, in a mind-created appearance or symbolic entity, existing in itself in space and time and beyond time, according to the laws

105

of its own nature, which are the laws that preside over the coming into existence or into knowledge of essence. Essence, as far as the finite being is concerned, can be known only through its appearing or phenomenal appearance. The world of appearances reveals its truth only when the veil that lies between essence and appearance falls and makes it possible for the artist or the philosopher to catch a glimpse of true reality which, since it becomes known, not as being outside himself, but only through himself as subject, is finite in its apprehension, and eternal in its essence. The essence that informs existential reality is the absolute subject revealing itself for other subjects and for itself, through the intersubjectivity that reveals itself in time as part of its own growing self-knowledge.

This self-knowledge unfolds through the praxis of existence, and through mind, of which art is one manifestation. The others are philosophy and religion, and art partakes of both of these. It partakes of philosophy's search for truth, and it partakes of religion's aspirations or the mystical intoxication that plunges the creative subject into a trance-like yet extremely lucid state which connects him with true reality and enables him to translate his experience in terms of an organic, symbolic entity in which all the parts form a whole that is the receptacle of the truth of that moment. This artistic whole is composed of materials apprehended by the senses and by the imagination, and unprocessed by concepts that would destroy their organic life, to replace it by a kind of abstract mental life which, though the basis of philosophy, is antithetical to art. This being so, a work of art can be apprehended only through intuition or imagination, and not through the mere understanding, through concepts or scientific formulations.

This does not mean that art offers no scope to the understanding and to mental data gathered through concepts; it simply means that this latter type of knowledge is secondary, and that though it could add to the appreciation and value of a work of art, it is not by any means necessary to its basic aesthetic appreciation. For example, it seems evident that though knowledge of the history and of the philosophical thought of the period when Dante's *Divine Comedy* was written would enlarge and enrich the intellectual pleasure of

106

recognition to be derived from reading the poem, this knowledge could not add anything to the aesthetic appreciation of the poem, the beauty of which rests above all on the power of imagination. Its complex symbolic structure exhibits a quasi-divine harmony that implies an imagination of awe-inspiring range and scope, and an acuity of vision that has produced a most concise and vivid type of imagery, capable of bringing the reader into direct and illuminating contact with the essence of appearances. If one adds to these singular qualities a consuming love for the Divine and for creation, and a saint-like capacity, only granted to great mystics, to transcend the self's subjectivity and to merge it into intersubjectivity, one has here some of the traits that make it clear that art rests above all on imagination and purity of perception, and not on the understanding and conceptualisations, that are part of the world of science.

Science, also starting from observed facts and often from perceptions, organises facts according to the structures of the understanding. By conceptualising sense-data, it replaces the objects of perceptions by their abstract qualities and properties that are the prerequisite instruments of mental constructions, but that are totally separated from their concrete, living source, which is the only element upon which the creative imagination can feed. Art cannot include either concepts or conceptualism, which necessarily implies a finality alien to it. Art can have no other finality than that of realising itself and knowing itself as art, that is to say as the expression and revelation of a complex imaginative duration in the course of which creative subjectivity connects with the absolute and knows itself in the act of knowing itself. Science is the search for, and the discovery of, universal laws; art deals with the particular, and does not move beyond the particular, which is not the real, but essentialised symbolic reality, to which it confers universality, in the sense that it embodies truths that are universal. Art does not aim at reaching the universal through concepts and direct intellectual apprehension, but through the appearance of sensible particulars, directly apprehended by the imagination as appearances of the forms that it recognises in them, and that it welds together into the coherence of art.

Fundamentally, art is a translation of the invisible, the unheard or the virtual form of appearance or experience, into visible or audible, existential entities that are apprehensible to the senses. This has nothing to do with the notion of art for art's sake, a notion which is without foundation, generally taken to mean that the artist withdraws from the world into an ivory tower, disconnected from any possible contacts with society or with his fellow beings, and indulges in the creation of toy-like artefacts, purely for his own satisfaction and appreciation. Such a dream-like detachment from the earth and from mankind, to which the artist necessarily belongs, cannot be. The artist, whether he likes it or not, is part of society, and whether he consciously seeks to opt out of it, or to integrate himself in it, he can only express a fully committed attitude of mind towards it. If, for instance, he seeks to devote himself to his art by pretending not to care about society, his art will express only his escapism and a-sociability, that is to say his own attitude to society, for, as Aristotle put it, man is a political animal, and art can never be totally meaningless or a-social; whatever aspect it takes, it always has a meaning as the social activity of an unavoidably social being.

The notion of art for art's sake that had currency at the end of the nineteenth century was certainly as meaningful then as naturalism or academism. Zola's naturalism was politically and socially orientated; it aimed at describing and correcting the ills of the society in which he lived. Mallarmé's transcendentalism, and Flaubert's cult of the beautiful and of impersonality, were just as important social reactions as Zola's. Mallarmé's attitude perfectly typifies the disgust and revulsion of an exacerbated type of artistic sensibility towards the crude materialism, levity and superficiality of the bourgeois-dominated society. Instead of berating it, or directly trying to change it through an art that would exhibit and attempt to correct its misdeeds and injustices, the artist withdraws into a type of art that abolishes reality and replaces it by the reality of the mind, whose existence is confined to the creative moment, which is the creative subject knowing itself as a projection from negated reality towards negated transcendence. The creative act becomes an act of self-created transcendence rising from negated reality to non-being; it is

nihilism made transcendent, and it is a most radical condemnation of society, implying that there is absolutely no hope of recuperation or salvation, unlike the attitudes of Zola and, to a certain extent, Flaubert. The only conclusion is that society should be totally destroyed, so that whatever is left of mankind could start again.

The artist's theory of art for art's sake, that is to say the theory that posits a monk-like devotion to the search for artistic beauty, uncontaminated by conceptual intrusions or aims, except that of achieving beauty by allowing the material and the characters the artist is handling to work out their conflicts and tensions without any interference from the creator, is no doubt a form of escapism through art. This suggests that there is something to escape from, and this something is society and the time in which the artist lives; therefore escapism is an a-social attitude. The artist's task is to search for knowledge through art, and this is what is meant by art being its own end, in the same way as pure science is its own end: it simply means that neither should be used as a moralising, political or commercial instrument, or as a means of gratifying selfish ends; each should be used only in the search for disinterested truth.

The truth of art lies in the purity of its search, which rests on the absolutely free life of the various forms involved. These are the form or essence of the creative mind and the form of the experience to which the creative mind seeks to give a sensible appearance, and finally the form of the material it is using. These forms or essences are part of spirit, which informs creation and which manifests itself fragmentarily through finite artistic subjectivities that, when they commune with and express being, temporarily participate in its universality and in the knowledge of their own true reality. This continuous interplay of spirit or intersubjectivity and individual subjectivity illumines man's journey and progressively, through concrete phenomenal appearances, reveals to him the truth of his being. These appearances are not merely phenomenal appearances, for that would be pure naturalism or empty, conceptual formalism; they are phenomenal appearances grasped by the imagination, which fuses their forms with its own inner forms and structures, and therefore transmutes

109

them and turns them into organic entities that are neither representations or imitations of natural phenomena nor mental creations. They are entities that have their own life and their own essential appearance or image, which is neither illusion nor a copy of reality, but a subjectively created and informed phenomenal reality. Transcendence is accessible neither to the senses nor to the understanding; the awareness of its presence can be reached only by a subjectivity aware of its essence, that is to say aware of its own connection with transcendence, as the source of the subsistent essence that informs creation.

Art's discovery of truth is not that of science; it is a discovery that entails other means and other journeys, and concerning which the criterion is not the journey or the means used — something beyond any possible mathematical or logical assessment and control — but the effect and import of the final result. There is no recipe or formula by which a subjectivity can, subconsciously or consciously, place itself in a state of naked receptivity, so as to be permeated by the essence of ambient reality and connect with the essence that informs both reality and itself as part of it. Yet the whole history of mankind shows that such moments of revelation or access to true knowledge have always been part of man's life. To deny their existence would be to deny man's greatest achievements, the achievements that have fed his spirituality, led him continuously to develop it and to increase it until, finally, Being has reached through creation total self-knowledge. The light that guides man's journey through time comes from his soul, living in time and apprehending, from time, glimpses of the infinity which underlies and slowly unfolds time. Subjectivity, in artistic experience, is the reflection of intersubjectivity or transcendence, knowing itself as human subjectivity, part of time and transcending time. God Himself cannot be conceived of as totally enclosed in perfect identity with Himself, in eternal perfection and stillness. He can be conceived of only as continuous spiritual activity manifesting itself through what is other than itself, in order to know itself. Nature and creation are part of this process of continuous self-knowledge through God's immanent activity in them. This activity takes place through the Incarnation — Christ — as the otherness of God,

110

and the Holy Spirit, both being progressively reintegrated in God, through action that is self-knowledge.

Truth is the actualisation of the idea or form that informs it. There is no truth without action. A tree is the actualisation of its seed. A work of art is the actualisation of the forms that inform it, and an idea is true if the mind succeeds in objectifying it, either through actualisation in life or through its capacity to integrate this idea as part of a mental system that corresponds, in varying degrees, to reality. If this cannot be done, then this idea is merely an abstraction, a mental figment, without any relation to reality; whatever the domain, it is always actualisation that confers truth and knowledge. Actualisation is actualisation of form, which necessarily contains the positive and the negative, the thesis and the antithesis, and in the end the bad is always resorbed into the positiveness of the good. This implies totality of action as opposed to fragmentation, which confines itself to isolated aspects only. In such a case, one may have knowledge of given aspects, but one does not have truth, one has only its shadow without the true substance that makes truth. To know is to re-unite, to re-cognise what truly is, and for the philosopher, the leader of men, or the artist who possesses the vision to see what is, Nature and man are one, informed with transcendence and intertwined by bonds that make it possible for man as mind to know or to re-cognise the structure of the other, which is Nature.

Mind does not lose itself or dissolve itself in Nature, in some vague pantheistic equivalence of Nature with spirit. On the contrary, it actualises itself, or rather it re-cognises its own essence in Nature, and by recognising it and assimilating it to its own structures, which correspond to those of Nature, it gives itself a content that has absorbed its form, and that, at that very moment, is part of Mind itself, transcending all subjectivities. This is the process of the creative act, in the course of which the inner *I* of the creative subject projects his own essence towards something that is other than himself, and re-cognises its form through actualisation in a construct, which is an act of self-knowledge in which the subject knows himself both as being-for-himself as other, and also as an objective being for others. Art is not, like science, a matter of

111

observation, or a discovery or rediscovery of the laws of Nature and of the workings of matter, objectively grasped by the understanding, that is to say, as Plato put it, 'itself according to itself', with little or no intrusion of the subject. Art is a closing down of the senses; it is vision without eyes, or the music without sounds of Plato, the neo-Platonists and the great mystics. 'We are not in this world to see, but not to see', said St John of the Cross; 'The glare of daylight would spoil my inner light', replied El Greco to a friend who asked him to go for a walk.

No painter has equalled Rembrandt in his attempt to reveal to man the depth of his spirituality and the light that illumines his being. Whether he paints himself, as he has so often done, directly in self-portraits or as the Falconer, St James or St Matthew, or indirectly through Faust, Tobias, Homer or the Philosopher in Meditation, the only thing that matters is the mystery of the light on the face, the eyes and the hands; the rest of the painting, together with the body, already old and practically worn out, generally fades into darkness as the body will soon fade into a shade. Appearances, bodies, the world are obviously of no importance; what matters is the light—what Heraclitus called the creative lightning—that illumines them, and this light is not a matter of eyes and perceptions. St James keeps his eyes shut, Tobias is blind, Homer is blind, yet they all are radiant with light; and the painter, as St Matthew, looks blank and listens to the angel, or sees with his mind's eye the vision of Daniel, illumined by a spiritual other-worldly light that transcends the material world and its laws. This light is that of the creative imagination, which 'bodies forth the forms of things unknown'. It is what Blake meant: 'Man perceives more than the senses can discover'; it is the light that impelled Keats: 'I am certain of nothing but the holiness of the heart's affection and the truth of the imagination'; it is the light of Picasso: 'One ought to put out the eyes of painters as they put out the eyes of goldfinches, to improve their singing . . . To draw, you must close your eyes and sing.' This is the light that all true artists have followed, from the cave-painters to blind Homer and Milton, Rembrandt, El Greco, Victor Hugo and Yeats.

112

Conclusion

> How weak are words, and how unfit to frame
> my concept[1]
>
> DANTE, *Paradiso,* Canto XXXIII

The age that produced Rodin, Matisse, Rouault, Kandinsky, Klee, Chagall, Picasso, Braque, Henry Moore, Lawrence, Joyce, Yeats, Proust, Valéry, Claudel, Thomas Mann, Eliot and Malraux, to quote only a few, came to a close about a generation ago. Although sensibility was then fragmented, art, whatever form it took, sought to relate this sensibility to the deep reality of social life and history, and to express universal aspects of truth. Picasso's *Guernica*, like Goya's *The Shooting of May 3rd*, expresses, in terms of contemporary sensibility and style, the savagery and irrationality of his age, and the collapse of values of Western civilisation, which had lost its centre and had broken down into obscene, disparate elements. Like Cézanne before him, like Braque and Klee, Picasso seeks to express the inner reality of things, recreated by him and reduced to their structural, geometric forms. Without professing any religious faith — although he is religious in his own way — his imagination sees creation as a whole, informed with a daemonic spirit intent upon taking to bits the original work of the Creator. Whether they are believers or non-believers, all great artists have an awareness of and an aspiration towards transcendence, and Klee speaks for every one of them when he says: 'The artist thus creates or participates in the creation of works which are the image of God's creation . . . The artist and his work become part of the totality of Being through an action which they perform and which makes them.'[2]

At this moment, in the East, the serenity of Buddha is deeply disturbed by Western technology and materialism, awakening appetites alien to its spirit. In the West, the Passion

113

of Christ and His love for the whole man are, to a certain extent, reduced to the love of riches and of the senses, which He had so fiercely condemned. Islamic brotherhood is merely a brotherhood in arms; Africa is fragmented; only imperial China steadily follows its millenary way, wrapped up in its own vision of life and destiny. Civilisations the world over tend more and more towards forming a single, fluctuating mass, affected by problems of world-wide range, and by currents that are intermingled and transcend all frontiers. Art reflects this shapelessness and this lack of identity and spirituality; it is without style and without boundaries, in continuous flux. A style implies a widely accepted attitude to life, to its meaning and its finality. There is now neither consensus of meaning nor, least of all, consensus of finality. At this point in time, man is; that is all. Who he is, whence he comes, where he is going, are idle questions. To be is quite enough, and there is no time to think about what one is or will be, about tomorrow, or beyond tomorrow. 'To be' means to be today, without caring about yesterday or tomorrow, which are meaningless in a world that rejects the past, obfuscates the future and is concerned only with the synchronic present.

Art now is made up of images seen merely by the eyes but not by the imagination, and sensations without depth, unconnected with any living, organic reality and aiming at an instantaneous impact. Gone is the Cartesian *I* which held all aspects of consciousness together and provided man with his awareness of being. Man gets his awareness of being through sensations which dart on and off through the surface of his mind, like will o' the wisps on stagnant pools; one brief illumination and then they disappear, leaving behind them despair or dull darkness, according to the rhythm of the heart. Art reflects this lack of organicism and substructure of being, and it expresses the disintegration and crumbling of a civilisation reduced to fragments that the artist tries to shore up as a mausoleum to his own individual name. Artistic subjectivity is no longer the immanent and transcendental subjectivity of Romanticism; it is a shallow, self-sufficient, personal egotism, disconnected from being and concerned only with the assertion of its own instant sensations, dreams, pains, anxiety or violence, represented by signs, images, colours or symbols

114

without reference to any widely accepted and recognisable style. Thus we have a flurry of appearances or shapes, or a mere imitation of Brownian movement, expressing both the gratification of egotistical appetites and ambitions, and the barrenness of spirit deprived of any contact with intersubjectivity, ground of true artistic, philosophical or religious knowledge.

The breakdown of reason, a process already evident at the end of the nineteenth century and accelerated in this one by World Wars, by Cubism, Surrealism and subjectivism, is by now complete as far as the arts are concerned. Picasso's art, which ranges from the representational art of his early period, through the cerebralism and intellectualism of his Cubist phase, to his daemonic 'deconstruction' of reality or of already existing paintings of his later period, covers the whole range of twentieth-century art, and puts a full-stop to a long period of Western art, which will have either to find new directions or to fade away into technology and functionalism. Since there is no longer any belief in rationality or the wholeness of life, art is merely the expression of individual subjectivity through mental constructions made out of pieces of reality or of existing works of art. These constructions are contrived in the extreme, and their novelty is that of the crossword puzzle, in which the notion of the whole comes to mind through the recognition of the broken bits that compose it. Cocteau's and Diaghilev's notorious preoccupation with continuous surprise, shared by *haute couture* and summed up by Picasso with the words: 'One has the right to do whatever one likes provided one never does the same thing', has become the new conformism of the age, and it is of course as conventional as Victorian church-going, and just as shallow and barren. Novelty has become a value in itself. The notion of a 'work of art' is no longer valid; art is a means to an end; its object is to achieve surprise, notoriety or wealth, through all sorts of devices—objects, toys or games. The 'natural art' of Dubuffet, the 'collages', the 'montages', the 'happenings', the painting of food cans, the exhibition of everyday objects in art galleries or the labelling of these objects as works of art, imply no totality of being and no search for truth. They are like rock-and-roll music—a satisfying physical exercise; they are not art, but

115

fragments of matter without any organic, living wholeness or roots in reality. Now there is nothing but the gesture to attract attention, the cult of sensations, and there is anti-art in all its forms. There is anti-poetry, anti-painting, anti-theatre, anti-novel, anti-philosophy or what is called 'deconstruction' of philosophic systems, or philosophy as science, and there are linguistic analyses and psychoanalyses as sources of art.

Following the ascendancy of existentialist subjectivism and Marxist immanentism with its valorisation of history and of the real, we have now a primacy of the contingent, the theoretical, the didactic in art as well as in philosophy. The real is no longer the lived, the Bergsonian duration or the transcendental instant of consciousness, but the intellect elaborating structures or abstractions that reduce all aspects of life to an interplay of systems, underlain by one single master system which, somehow, will have to reveal itself, since man, according to current theories, is no longer there to do so. This system seems to be an extraordinary self-caused, self-perpetuating, transcendental abstraction in which thought thinks itself, language speaks or writes itself and, by so doing, expresses the epistemological structure of every aspect of historical life. Just as for Mallarmé life seemed to exist only to culminate in 'le livre', in the kind of philosophical thinking that is particularly alive in France at this moment, life seems to exist only in order to be reduced to a system, in which language is, like the Egyptian snake biting its tail, a perfectly closed world, which could very well be the Pythagorean golden number embodying the secret of the universe. The various systems that represent all aspects of life bathe in a kind of synchronism which excludes diachronism, and are, like Achilles' motionless strides or Zeno's arrow, an infinite of finites unable to connect in order to give human life coherence and finality. These separate systems are not monads, for monads are parts of the universal harmony, which is rational, moral, continuously changing, informed with the Divine, and forming a whole in which the parts can be known only through their relation to the whole. The complexity and organicism of reality and the continuous dialectical unfolding of man's mental and affective life, and of the forces that make history, are reduced to theoretical structures or models, binary oppositions or double

116

contradictions, under the cloak of a scientific apparatus and an apparent linguistic rigour that is neither philosophy nor art, but merely a metalanguage used to decode the semiological signs of the present or of the past, so as to discover their respective epistemological structures.

In such a context, the critic and the commentator tend to take the place of the creator, and whether in art or in philosophy, it is more important to know what they say than to know the work they discuss. So we have films about film-making, novels about novel-writing, paintings about painting, and theoretical linguistic codes for extracting the best out of Racine's or Baudelaire's poetry. Everything is at one remove from the concrete. Art, which can only live on the particular and the real, is all too often reduced to intellectual abstractions, and the same goes for philosophy, which, in all its aspects — ontology, epistemology, aesthetics and politics — should always start from the real in order to elaborate systems that can offer rational explanations of man's mind, his psyche or the way in which he creates art or makes history. One cannot replace man by tautologies about the intellect or systems, for they both emanate from him, and he possesses not only an intellect but a heart and instincts and passions, which must have their say in all the aspects of life, which is a continuous unfolding of the complex energies of multiform matter endowed with a teleology transcending human thought. It is only man as an integrated whole, endowed with Kantian 'schemes' that relate his mind to the cosmos, who can weld together scientific phenomenalism and experimentalism with the epistemology of being. The will to theorise in the abstract and to reduce life to systems is merely an expression of the egotistic will to power which worships itself as the mental abstraction that it hypostatises. This is an attempt, quite in keeping with certain aspects of the nihilism of our age, to create each our own individual values, and to impose, in the name of reason, a form of irrationalism that fragments the organic reality of life and tries to reduce it to easily manageable formulae and systems. It is a search, not new, for a pseudo-mental absolute that is merely a compound of egotistical relativism and teleology, the aim of which is the discovery of a master system which, in other terms, might not

be very different from the mediating logos of St Augustine or Leibniz, the clock-maker of Descartes, the Absolute of Hegel, or the becoming of Plato and Heraclitus.

Our age might remain notorious in history for the industriousness it displays in trying to turn its failings into virtues. Yet of course, all these exertions cannot finally mask anxieties and questions unanswered, and there is a lurking awareness that such questions can be neither silenced nor ignored. Whether God is an idea inherent in man, so that, as Pascal said, we should not search for Him unless we had already found Him, or whether He is, as some say, a mere figment of the imagination, the result seems to be the same: somehow man needs God, as no doubt God needs man. The present search for mystical or para-mystical experience through Eastern religions or disciplines, or through drugs or other means, makes it clear that men cannot confine knowledge and life itself to matter and appearances.

Scientists like Einstein have shown the way, and some are growing more and more aware that the world of things and their appearances is not all, and that their true nature evades their measurements. These minds are aware that one can adopt neither pure Berkeleyanism, and look upon the world as a subjective representation, nor pure materialism, and look upon consciousness as an epiphenomenon of matter. Consciousness and matter have their own existence, but they can truly exist only through their interrelationship. Matter by itself merely is; it has no moral attributes or values, and consciousness by itself is pure being, unaware of the existence of non-being, and therefore unaware of existence itself. Science, by concentrating upon matter, ignores the true reality of things. Art gives pre-eminence to this reality and to consciousness, which shapes the object of its knowing, and knows itself through this object in the same way as the true religious mind knows itself only through God. Men will more and more come to realise that creation exhibits continuity and rational interrelationships, that there is a force which informs the whole, and that those who seek to discover its nature and to become aware of it are likely to be more attuned to life, and thus to live a more rewarding and richer life, than those who ignore or deny it.

Notes

Chapter 1: 'Art and the Artist'

1. W. B. Yeats, *Autobiographies,* Macmillan (London) 1926, p. 143.
2. W. H. Auden, *Forewords and Afterwords,* Faber (London) 1973, pp. 88-90.
3. Quoted by André Malraux, *La Corde et la Souris,* Gallimard (Paris) 1976, p. 366.
4. Lucien Goldmann, *Marxisme et Sciences Humaines,* Gallimard (Paris) 1970, pp. 61-2.

Chapter 2: 'What is Art?'

1. Galileo Galilei, *Dialogo dei due Massimi Sistemi del Mondo*; Le Opere di Galileo Galilei, Ed. Nazionale (Florence) 1933, vol. 6, p. 129.
2. Arthur Schopenhauer, *The World as Will* I, quoted by Nietzsche, *The Birth of Tragedy,* Doubleday (New York) 1956, p. 99.
3. Quoted by René Huyghe, *Dialogue avec le Visible,* Flammarion (Paris) 1955, p. 207.

Chapter 3: 'The Perenniality of Art'

1. Plato, *Timaeus,* 28b.
2. Quoted by Martin Heidegger, *Existence and Being,* Vision Press (London) 1949, pp. 300, 308.
3. Plato, *Republic,* VI, 504c.
4. Plato, *Laws,* IV, 716c.

Chapter 4: 'Art and Subjectivity'

1. G. Santayana, *Three Philosophical Poets* (Harvard) 1910, p. 34.
2. *Plotinus,* trans. Stephen MacKenna (London) 1917-30, vol. II, p. 67.
3. V. Hugo, Preface to *Les Contemplations.*

Chapter 5: 'Art and Knowledge'

1. A. N. Whitehead, *Modes of Thought,* Cambridge University Press (Cambridge) p. 238.
2. Hans Arp, *Collected French Writings,* ed. Marcel Jean, Calder and Boyars (London) 1974, p. 241.
3. Paul Valéry, *Degas, Danse, Dessin,* Gillimard (Paris) 1946, p. 123.
4. Quoted by Kathleen Raine, *William Blake,* Thames and Hudson (London) 1970, p. 8.

Conclusion:

1. Dante, *Paradiso,* Canto XXXIII, trans. Dorothy Sayers and Barbara Reynolds (London) 1962.
2. Paul Klee, *The Thinking Eye,* Witterborn (New York) 1961.

Chronology

Painters and sculptors

Altamira 30,000-10,000 BC
Lascaux 16,000-10,000 BC

Minoan Art ⎫
Egyptian Art ⎬ 5000-2000 BC
Sumerian Art ⎭
Mycenian Art 2000 BC
Later Minoan 1500 BC
Pheidias *d.* 431 BC
Apelles *b.* 400 BC
Praxiteles *b.* 390 BC

Thinkers

Thales 640-547 BC
Anaximander 610-547 BC

Lao-Tse *c.* 600 BC
Pythagoras 580-500 BC
Heraclitus 576-480 BC
Confucius 551-479 BC
Parmenides 540-450 BC
Protagoras 485-410 BC
Zeno 480-430 BC
Empedocles 5th cent. BC
Democritus 5th cent. BC
Socrates 469-399 BC
Plato 428-348 BC
Aristotle 384-322 BC
Epicurus 341-270 BC

Plotinus *c.* 205-*c.* 270 AD
St Augustine 354-430 AD
Scot Erigena *c.* 830-*c.* 880 AD
Abelard 1079-1142

Writers

Homer 9th cent. BC

Aeschylus 525-456 BC
Sophocles 495-406 BC
Euripides 480-406 BC
Thucydides 465-395 BC
Aristophanes 445-386 BC
Herodotus *c.* 425 BC
Virgil 70-19 BC
Horace 65-8 BC

Founders of religion

Buddha 567-487 BC

Jesus Christ *c.* 4 BC-27 AD

Mohammed 570-632 AD

Painters and sculptors	Thinkers	Writers	Composers
Giotto 1276-1319	Roger Bacon 1214-1294	Dante 1265-1321	
Simone Martini 1285-1344	Aquinas 1225-1294	Petrarch 1304-1374	
Ghiberti 1378-1456	Ockham 1300-1349	Boccaccio 1313-1400	
Van Eyck 1385-1440		Chaucer 1340-1400	
Donatello 1386-1466			
Fra Angelico 1387-1455			
Uccello 1396-1475			
Piero della Francesca 1415-1492	Savonarola 1452-1498	Villon 1431-1465	Dufay c. 1400-1474
Fouquet 1420-1480	Copernicus 1473-1543	Ariosto 1474-1533	Dunstable ?-1453
Memlinc 1430-1494	Luther 1483-1546	Rabelais 1494-1553	Obrecht 1430-1505
Bramante 1444-1514			Okegham c. 1430-1495
da Vinci 1452-1519			Josquin des Près 1450-1521
Dürer 1471-1528			
Michelangelo 1475-1564			
Titian 1477-1576			
Giorgione 1478-1510			
Raphael 1483-1520			
Tintoretto 1518-1594	Calvin 1509-1564	Scève 1501-1560	Gabrieli 1510-1586
Veronese 1528-1588	Bruno 1548-1600	Ronsard 1524-1585	Palestrina 1525-1594
El Greco 1540-1614	Galileo 1564-1642	Montaigne 1533-1592	Byrd 1542-1623
Rubens 1577-1640	Kepler 1571-1630	Tasso 1544-1595	Dowland 1563-1626
Le Nain 1593-1648	Boehme 1575-1642	Cervantes 1547-1616	Monteverdi 1567-1643
La Tour 1593-1662	Hobbes 1588-1679	Lope de Vega 1562-1635	Gibbons 1583-1625
Poussin 1594-1665	Descartes 1596-1650	Shakespeare 1564-1616	Schütz 1585-1672

Painters and sculptors

Bernini 1599-1680
Velasquez 1599-1660

Rembrandt 1606-1682
Murillo 1618-1682
Vermeer 1632-1678
Tiepolo 1696-1770
Canaletto 1697-1768
Hogarth 1697-1764
Chardin 1699-1779

Reynolds 1723-1792
Gainsborough 1727-1788
Fragonard 1732-1805
Goya 1746-1826
David 1748-1825
Raeburn 1756-1823
Blake 1757-1827
Turner 1775-1851
Constable 1776-1837
Ingres 1780-1876
Corot 1796-1875
Delacroix 1798-1863

Thinkers

Pascal 1623-1662
Locke 1632-1704
Spinoza 1632-1677
Malebranche 1638-1715
Newton 1642-1727
Leibniz 1646-1716
Vico 1658-1744
Berkeley 1685-1753
Swedenborg 1688-1772

Hume 1711-1776
Rousseau 1712-1778
Kant 1724-1804
Fichte 1762-1814
Maine de Biran 1766-1824
Hegel 1770-1831
Schelling 1775-1854
Schopenhauer 1788-1860
Comte 1798-1857

Writers

Donne 1573-1631

Calderon 1600-1681
Corneille 1606-1684
Milton 1608-1674
Molière 1622-1673
Bunyan 1628-1688
Racine 1639-1699
Swift 1667-1745
Marivaux 1688-1763
Pope 1688-1744
Voltaire 1694-1778

Fielding 1707-1754
Diderot 1713-1784
Beaumarchais 1732-1791
Goethe 1749-1832
Blake 1757-1827
Burns 1759-1796
Schiller 1759-1805
Hölderlin 1770-1843
Wordsworth 1770-1850
Coleridge 1772-1834
Chateaubriand 1768-1848
Stendhal 1783-1842
Manzoni 1785-1873

Composers

Lully 1632-1687
Purcell 1655-1695
Couperin 1668-1733
Rameau 1683-1764
Bach 1685-1750
Handel 1685-1759

Gluck 1714-1787
Haydn 1732-1791
Mozart 1756-1791
Beethoven 1770-1827
Rossini 1792-1868
Schubert 1797-1828
Donizetti 1797-1848

Painters and sculptors	Thinkers	Writers	Composers
Millais 1829-1896	Mill 1806-1873	Shelley 1792-1822	Mendelssohn 1809-1847
Degas 1834-1917	Darwin 1809-1882	Keats 1795-1821	Chopin 1810-1849
Cézanne 1839-1906	Kierkegaard 1813-1855	Austen 1795-1817	Schumann 1810-1856
Monet 1840-1926	Marx 1818-1883	Balzac 1799-1851	Liszt 1811-1856
Rodin 1840-1917	Spencer 1820-1903	Pushkin 1799-1837	Wagner 1813-1883
Renoir 1841-1919	Engels 1820-1895	Hugo 1802-1885	Verdi 1813-1901
Rousseau 1844-1910	Nietzsche 1844-1900	Gogol 1809-1852	Berlioz 1813-1869
Gauguin 1848-1903	Freud 1856-1939	Tennyson 1809-1892	Bruckner 1824-1896
Van Gogh 1853-1890	Husserl 1859-1938	Dickens 1812-1870	Brahms 1837-1897
Kandinsky 1866-1942	Bergson 1859-1941	Melville 1819-1891	Tchaikovsky 1840-1893
Matisse 1869-1954	Russell 1872-1970	Dostoevsky 1821-1881	Dvořák 1841-1904
Klee 1879-1940	Jung 1875-1961	Flaubert 1821-1880	Elgar 1857-1934
Picasso 1881-1973	Einstein 1879-1955	Baudelaire 1821-1867	Mahler 1860-1911
Braque 1882-1963	Heidegger 1889-1976	Ibsen 1828-1906	Debussy 1862-1918
Moore 1898-	Wittgenstein 1889-1951	Tolstoy 1828-1910	Sibelius 1865-1957
		Mallarmé 1842-1898	Rachmaninov 1873-1943
		James 1843-1916	Schönberg 1874-1951
		Rimbaud 1854-1891	Ives 1874-1954
		Conrad 1857-1924	Ravel 1875-1937
		Chekhov 1860-1904	Bartók 1881-1945
		Pirandello 1867-1936	Stravinsky 1882-1971
		Proust 1871-1922	Webern 1883-1945
		Valéry 1871-1945	
		Rilke 1875-1926	
		Mann 1875-1955	
		Joyce 1882-1941	
		Kafka 1883-1924	

Painters and sculptors	Thinkers	Writers	Composers
Giacometti 1901-1966	Sartre 1905-	Lawrence 1885-1930	Copland 1900-
		Eliot 1888-1965	Shostakovich 1906-1976
		MacDiarmid 1892-	Messiaen 1908-
		Faulkner 1897-1962	Britten 1913-
		Malraux 1901-	

Select Bibliography

Alexander S., *Beauty and Other Forms of Value*, London, 1933; New York, n.d.

Ayer A. J., *Language, Truth and Logic*, London, 1950; New York, 1936.

Philosophy and Language, London, 1960.

Baudelaire C., *Curiosités Esthétiques*, ed. H. Lemaitre, Paris, 1962.

Blake W., *The Complete Works of William Blake*, ed. Keynes, London and New York, 1966.

Bradley A. C., *Oxford Lectures on Poetry*, London, 1909; New York, 1934.

Brooks Cleanth, *The Well-Wrought Urn*, London, 1968; New York, 1947.

Cassirer E., *Philosophy of Symbolic Forms*, trans. R. Manheim, London, 1953; New-Haven, 1958.

Coleridge S., *Biographia Literaria*, London, 1947; New York, n.d.

Collingwood R. G., *The Principles of Art*, London, 1950; New York, 1958.

The Philosophy of History, London, 1950.

Croce Bendetto, *Aesthetics*, trans. D. Ainslie, London, 1922; New York, 1965.

Dewey J., *Art as Experience*, New York, 1934.

Eliot T. S., *Selected Essays*, London, 1951; New York, 1950.

On Poetry and Poets, London and New York, 1957.

To Criticize the Critic, London and New York, 1965.

Focillon Henri, *The Life of Forms*, trans. C. B. Hogan, New York, 1946.

Freud S., *Civilization and its Discontents*, London, 1930; New York, 1962.

Leonardo da Vinci, London, 1948; New York, 1966.

Goldmann L., *Hidden God,* London and New York, 1964.

Pour une Sociologie du Roman, Paris, 1967.

Gombrich E. H., *Art and Illusion*, London, 1960; New York, 1961.

Meditation on a Hobby Horse, London, 1963.

Norm and Form: Studies in the Art of the Renaissance, London and New York, 1966.

The Story of Art, London, 1967; New York, 1974.

Symbolic Images, London and New York, 1972.

Hampshire Stuart, *Thought and Action*, London, 1951; New York, 1960.

Feeling and Expression, London, 1960.

Freedom of the Individual, London, 1965; New York, 1975.

Hegel G. W. F., *Philosophy of True Art*, trans. B. Bosanquet, London, 1886.

Heidegger M., *Existence and Being*, London, 1949; New York, 1950.

Huyghe R., *Dialogue avec le Visible*, Paris, 1955.

Jung C. G., *Modern Man in Search of a Soul,* London, 1933; New York, 1955.

Analytical Psychology, London, 1968; New York, 1970.

Kant I., *Critique of Judgment*, trans. Meredith, Oxford, 1928; New York, 1952.

Langer S., *An Introduction to Symbolic Logic,* London, 1927; New York, 1953.

Philosophy in a New Key, London, 1957; Cambridge, Mass., 1942.

Problems of Art, London and New York, 1957.

Feeling and Form, London and New York, 1953.

Reflections on Art, London, 1958; New York, 1961.

Lukacs G., *The Historical Novel*, trans. H. and S. Mitchell, London, 1969; New York, 1965.

Studies in European Realism, London, 1950; New York, 1964.

Goethe and his Age, London, 1968.

The Meaning of Contemporary Realism, London, 1968; as *Realism in Our Time*, New York, 1971.

Malraux A., *The Voices of Silence*, trans. Stuart Gilbert, London, 1954; New York, n.d.

L'Irréel, Paris, 1974.

Maritain Jacques, *Art et Scolastique*, Paris, 1935.

Creative Intuition in Art and Poetry, London, 1969; New York, 1953.

Merleau-Ponty M., *Signes*, Paris, 1960.

L'Oeil et l'Esprit, Paris, 1964.

Panovsky E., *Renaissance and Renascences in Western Art,* London, 1970; New York, 1972.

Plato, *Oeuvres Complètes*, ed. L. Robin, 2 vols., Paris, 1964.

Raine K., *William Blake*, London, 1970; New York, 1971.

Read H., *Form in Modern Poetry*, London, 1948; New York, 1932.

Icon and Idea, London, 1955; New York, 1965.

The Meaning of Art, London, 1957; New York, 1972.

Art Now, London and New York, 1960.

The Philosophy of Modern Art, London, 1965; New York, 1953.

Santayana G., *The Sense of Beauty*, London, n.d.; New York, 1896.

Three Philosophical Poets, Harvard, 1927.

Sartre J.-P., *The Psychology of Imagination*, trans. B. Frechtman, London, 1949; New York, n.d.

Toynbee A., *A Study of History*, Oxford and New York, 1972.

Valéry P., *Pièces sur l'Art*, Paris, 1936.

Degas, Danse, Dessin, Paris, 1938.

Waddington C. H., *Behind Appearance*, Edinburgh and New York, 1970.

Whitehead A. N., *Symbolism, its Meanings and Effect*; London, 1928; New York, 1959.

Wittgenstein L., *Philosophical Investigations*, ed. G. E. M. Anscombe, Oxford, 1953; New York, 1973.

Wölfflin H., *Classic Art*, London, 1952; New York, 1968.

Wollheim R., *Art and its Objects*, London, 1968; New York, 1971.

On Art and the Mind, London, 1973; Harvard, 1974.

Yeats W. B., *Autobiographies*, London, 1926; New York, 1966.

Index

131